People from Our Side

People from Our Side

A life story with photographs by Peter Pisteolak
and oral biography by Dorothy Harley Eber

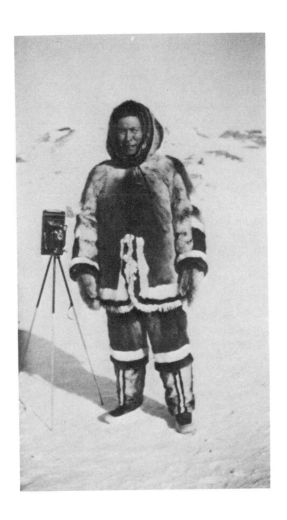

McGill-Queen's University Press
Montreal & Kingston • London • Buffalo

For the grandchildren

Nakashook, Palaya, Pudlo Peesee, Kitty, Pitseolak, Jimmy, Annie, Charlie, Johnny, Martha, Jeannie, Nina, Mark, Mary, Pudlo, Terry, Udluriak, Mary, Numa, Mark, Emily, Joe, Pauloose, Kavavow, Peter, Akavak, Annie, Uluta Udluriak, Aksutungwaq, Matteosie, Jamasee, Adamie, Atsiqtaq, Udluriak.

© Dorothy Harley Eber 1993
ISBN 0-7735-0996-8 (cloth)
ISBN 0-7735-1118-0 (paper)

Legal deposit second quarter 1993
Bibliothèque nationale du Québec

Printed in the United States on acid-free paper

Canadian Cataloguing in Publication Data

Pitseolak, Peter, 1902–1973
 People from our side: a life story with photographs and oral
biography
 New ed.
 Includes index.
 ISBN 0-7735-0996-8 (bound) – ISBN 0-7755-1118-0 (pbk.)
 1. Pitseolak, Peter, 1902–1973. 2. Inuit – Northwest Territories –
Cape Dorset. 3. Inuit – Northwest Territories – Cape Dorset –
Biography. I. Eber, Dorothy. II. Title.
E99.E7P54 1993 971.9′5 C93-090207-6

Front cover: Ice Fishing. Peter Pitseolak. One of a series of small-scale works in graphite, felt pen, and coloured pencil which the artist created circa 1967–73 using photographs as templates to illustrate traditional Inuit life. The figures here draw inspiration from photographs taken about 1958 (some appear on pages 114–15) which, according to Aggeok, show her daughter-in-law, Mary, "not really going fishing, just pretending to go fishing." Courtesy of the West Baffin Eskimo Co-operative

Back cover: Peter Pitseolak with his favourite camera, photographed about 1947 by his wife Aggeok. Notman Photographic Archives, McCord Museum of Canadian History

Translation of Peter Pitseolak's manuscript: Ann Hanson

Photographic advisor: Stanley Triggs, curator of photography, McCord Museum of Canadian History

Interpreters for interviews: Ann Hanson, Udjualuk Etidluie, Letia Parr, Annie Manning, Pia Pootoogook, Sapa Aliqui

Contents

Preface to the 1993 reprint

This reprinting of *People from Our Side* comes twenty years after Peter Pitseolak's death in Cape Dorset in 1973. Much has happened in the intervening period.

At the time of his death it was still uncertain whether this book would see publication. After a number of disappointments, however, the first edition appeared in 1975 under the imprint of the innovative publisher Mel Hurtig. An American edition, published by Indiana University Press, Bloomington, followed in 1977. Peter Pitseolak's photographs became increasingly well known but this book — with its story of changing times in Seekooseelak, where Peter Pitseolak, at eleven, saw the Hudson Bay Company's traders arrive in 1913 to set up their post in Cape Dorset — soon went out of print. But happily it was not forgotten As the fur trading era has become more distant, scholars have become more interested in searching out first-hand accounts of the period, and Peter Pitseolak stands almost alone in having provided an Inuit account of these days. Inuit readers from south Baffin Island say they find here family history and, in the pictures of Seekooseelak campers, family photographs. Marta Pudlat of Cape Dorset told me she could not remember her mother, Etooshajuk, who died of tuberculosis when she was a baby and had never seen her picture until she saw Peter Pitseolak's photograph on page 68. I am delighted with the decision of McGill-Queen's University Press to bring the book back into print.

Since their appearance here Peter Pitseolak's photographs have been the subject of a number of major exhibitions. At the time of his death, however, only a very few people outside Cape Dorset knew of the existence of the photographs or that Peter Pitseolak had been a passionate photographer. While he mentioned his photography from time to time during the interviews we did together and had identified a selection of key photographs, very little was known about his techniques and the cameras he used. He always referred to his cameras by the film he used, not by the manufacturer's name or lens opening. (His large, favourite "122" used 122 film and took postcard-sized pictures.) Much remained to be learned. Fortunately Aggeok Pitseolak (1906–1977) who, after Peter Pitseolak's initial experiments, became his principal developer and printer, was able to take up the story of how they improvised equipment and developed film in igloos, tents, and huts. Prior to publication of the book Aggeok and I worked together, with Letia Parr as interpreter, identifying many of the subjects of the photographs.

New and important information was also collected at the time of a small exhibition of new prints of Peter Pitseolak's work mounted by Stanley Triggs, curator of the Notman Photographic Archives, at the McCord Museum (now the McCord Museum of Canadian History). When Peter

A visual play on heraldic elements in the Hudson's Bay Company flag. Peter Pitseolak sometimes used this flag as a backdrop for photography (see page 143). In this drawing he has substituted rampant white foxes for rampant elks and an elongated golden star for the HBC coat of arms. The field behind is dark blue.
Collection of the West Baffin Eskimo Co-operative Ltd, on loan to the McMichael Canadian Art Collection.

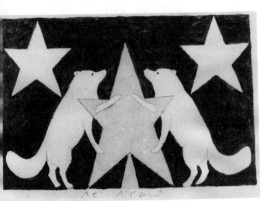

Pitseolak first sent a selection of negatives south, I had asked for help from the Archives, one of Canada's great photographic repositories. In 1975, as the result of negotiations conducted by the McCord, at the time under the acting directorship of Harriet Campbell, the Department of Secretary of State acquired 1623 of Peter Pitseolak's negatives — the size of the collection at the time was unknown and initial estimates varied from 1000 to 2000 — and a small number of original prints from the Pitseolak estate, placing them on deposit at the Notman. (The collection would certainly have been larger were it not for arctic conditions: "Sometimes in the hut it got very cold and then it would get very hot so some of the negatives got mildewed. I had to burn them. Because of my experience I knew what would print," Peter Pitseolak explained to me during one of our interviews.) The purchase was in accordance with his express wish that a way be found to ensure that the negatives be "kept safe." Stanley Triggs and his staff have given the negatives expert care ever since.

Aggeok, accompanied by interpreter Rosie Kelly, had come down from Baffin Island for the McCord's initial celebratory exhibition. The Archives' enlargements, beautifully printed by staff technician Tom Humphry, stirred memories and one evening, with Rosie interpreting, Aggeok talked in fascinating detail about Peter Pitseolak's early photography — "He was always inventive with his camera" — and I was able to record a key interview. This information has informed all later publications, starting with the American edition of this book.[1]

Preparation got underway for a further exhibition, "Peter Pitseolak: Inuit Historian of Seekooseelak," a retrospective of photographs and drawings shown first at the McCord and then at the Canadian Museum of Man (now the Canadian Museum of Civilization), a National Film Board film strip, and a pioneering travelling exhibition that took the photographs home to the North in a tour of thirty-one arctic settlement schools in both the eastern and western Arctic — photographs were mounted on folding screens specially designed to go through the smallest short take-off aircraft door. Further information was gathered from Kooyoo Ottochie, Peter Pitseolak's daughter, and Aggeok's son Ashevak Ezekiel (who is shown on page 42 acting out Cape Dorset's well remembered story of Taktillitak for Peter Pitseolak's camera). Others who were first-hand observers or participants in the photographic activities also supplied anecdotal material and sometimes photographic identifications.

1 Dorothy Eber, "Peter Pitseolak: Artist and Author," *The Beaver* (Winter 1975): 36–9; Dorothy Harley Eber, "How it Really Was," *Natural History* (February 1977): 70–5; David Bellman, ed., *Peter Pitseolak (1902–1973) Inuit Historian of Seekooseelak* (Montreal: McCord Museum, 1980).

Our knowledge of the photographs has continued to increase. Peter Pitseolak mentions in his manuscript (p. 108) that it was when "American people" were camped at Schooner Harbour in the winter of 1922 that he first heard of moving pictures. (These movies, of Greenland Eskimo, cowboys, and soldiers according to other Cape Dorset Inuit, were shown to appreciative audiences aboard the famous exploration ship *Bowdoin* when she wintered over on south Baffin Island and put in at Cape Dorset on her voyage along the coast.) After Peter Pitseolak's death I often wondered, as his written text was unclear, if he had actually seen these films himself. It was only during one of my last conversations with Kooyoo — she died in 1992 — that I learned that he certainly had and had often talked about them. We now know that both Robert Flaherty, the maker of *Nanook of the North*, whose presence on south Baffin Island Peter Pitseolak tells of here (pp. 87–8), and the films seen on the *Bowdoin* were early influences. "Those pictures were very old and my father thought if he took photographs they would last a long time like those movies," Kooyoo once told me. "He used to say that in the future people were not going to wear any more caribou clothing and he wanted to take pictures before it vanished so his grandchildren could see something of the old way." At one point Peter Pitseolak also possessed two movie cameras himself, but he told me he didn't enjoy them much "because you couldn't develop the film." (In the later stages of his photographic career he sometimes sent film or negatives "out" for processing, necessitating a wait of many months. He noted that one man entrusted with taking "some of the best negatives" down south was never heard from again. On another occasion, prints came back with a note saying there was no charge "because we have taken a picture.")

Increasingly Inuit recognize the photographs as a legacy. Stanley Triggs has described the photographs as "extremely valuable because they document the life of a community at a certain point in time and were taken by a member of the community itself — extremely rare in any society."[2] Work on the photographs continues. Field notes and identifications are being transferred to index cards and the collection is available to researchers. It is hoped that eventually all information will be cross-referenced and stored in a computer for easy use.

Since his death, interest in Peter Pitseolak's art work has also grown. This was sparked primarily by the return to Canada of a series of watercolour drawings (now in the collections of the Canadian Museum of Civilization) done about 1939 for the young John Buchan, son of Lord Tweedsmuir, Canada's Governor General, when he was a trader with the Cape Dorset

2 Eber, "How it Really Was," 70–5.

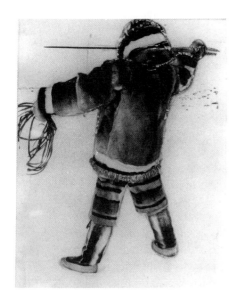

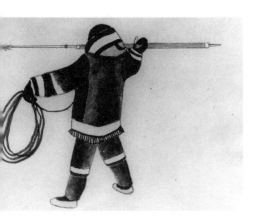

Hudson's Bay Company post. Almost certainly the earliest Inuit watercolours, they demonstrate remarkable skill and show how important the traders were to Inuit life of the period. Future students of Inuit art and culture will undoubtedly also be very interested in his illustrations of Inuit myths and legends, many with accompanying texts, and to a series of brilliant small-scale drawings in which he has employed — to stunning effect — photographs taken specifically to demonstrate Inuit life and traditional techniques. Peter Pitseolak had no need to copy, but he liked to make his art work ''real.''

The idea of using photographic templates was not new: in the early 1980s the late Lake Harbour hunter Isaccie Ikidluak, who appears in some of Peter Pitseolak's pictures, showed me an old photograph of three women, inscribed on the back to his grandmother Surusimiituq from the Rev. Archibald Fleming, later Bishop of the Arctic, who lived at Lake Harbour and photographed in the area for two two-year periods between 1909 and 1915. Each figure was heavily outlined in black pencil, suggesting that the photograph had supplied templates for incised pictures on ivory tusks, a speciality of Lake Harbour people. In Peter Pitseolak's series of drawings, photographs are used in a similar manner to depict the Inuit material culture, rendered in vivid colour. (Peter Pitseolak loved bright colours — he once made me a map of the northern arctic regions and on handing it to me remarked that he was sure I'd be surprised by his choice of colours: orange and red.) This series of some 40 drawings, in the collection of the West Baffin Eskimo Cooperative Ltd, is now on long-term loan to the McMichael Canadian Collection in Kleinburg, Ontario.

For the interpreters and myself, doing interviews with Peter Pitseolak was always a happy and invigorating experience. It could also be demanding. ''It's hard,'' Annie Manning once admitted when questioning her grandfather repeatedly about a phrase she was interpreting, ''but I keep on doing it so as not to be sorry later.'' We were always aware that we were hearing stories and learning of ''the old way'' from a master. Peter Pitseolak was, of course, capable of being difficult. ''I was always a driving man — one who gave orders,'' he once wrote about himself.[3] His fights with Sowmik — James Houston, who introduced Inuit art to the south — and with his brother-in-law Kavavow are legendary and had far-reaching effects.[4] But our work sessions were always harmonious: Peter Pitseolak patiently responded to even stupid questions, and with clever answers too! He is still

3 In Peter Pitseolak, *Peter Pitseolak's Escape from Death*, introduced and edited by Dorothy Eber (New York: Delacorte, and Toronto: McClelland and Stewart, 1977).

4 Dealt with here on page 145 and also in Dorothy Harley Eber, ''Images of Justice,'' *Natural History* (January 1990) and in Dorothy Harley Eber, ''Peter Pitseolak: A Historian for Seekooseelak,'' in Bellman, *Peter Pitseolak*.

talked about today all over Baffin Island and beyond. Many children have been called after him and after Aggeok. In Cape Dorset some of them attend the Peter Pitseolak School.

Since the summer I worked with Peter Pitseolak I have frequently thought of questions I should have asked and regretted lost opportunities. But if this book were published for the first time today I believe it would differ from the present volume only in one respect: the spelling of Inuit words. The system used here is phonetic; in the past twenty years a standardized roman orthography has developed and many place names have been changed back to the original Inuit name for the area. For example, Frobisher Bay is now Iqaluit, ''where there are schools of fish.''

This book owes a great debt to the talented linguists who assisted us every step of the way. Readers may be interested to know how distinguished some of those young people who collaborated with us twenty years ago have become: Annie Manning fulfilled her dream and became a teacher, the first native teacher in Cape Dorset; she also became one of Baffin Island's first female justices of the peace. (Many family members followed her lead into the teaching profession, including little Annie, Peter Pitseolak and Aggeok's adopted daughter, whose picture is on page 142. Peter Pitseolak gave up camp life and moved to the Cape Dorset settlement so Annie could go to school.) Udjualuk Etidluie became a religious leader, giving help and encouragment in difficult times, particularly to people battling drugs and alcohol. Ann Hanson, who translated Peter Pitseolak's syllabic manuscript and interpreted many of the interviews, went on to play many roles in the evolving North and recently finished a term as deputy commissioner of the Northwest Territories. While holding office she graduated from Arctic College in Iqaluit in journalism, sometimes faxing assignments from Yellowknife or other destinations where her duties took her. Without the help of all the interpreters who worked with us, this record of the last days of Seekooseelak could not have been accomplished.

Dorothy Harley Eber
Montreal, 1993.

People from Our Side

I am telling the true things I know.
I am not adding anything
and I am not holding anything back.

Peter Pitseolak
Cape Dorset, April 1973

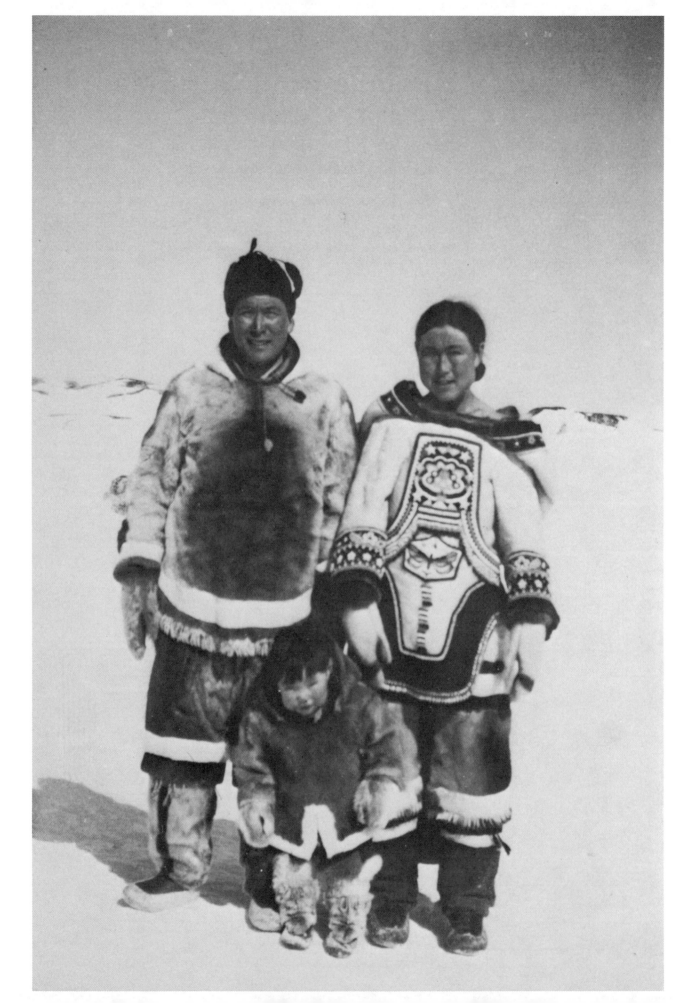

Peter Pitseolak, his wife Aggeok, and their adopted son Mark Tapungai. Probably taken by Udluriak Pitseolak Manning in 1945.

Mark Tapungai with the shadow of the photographer in the foreground.

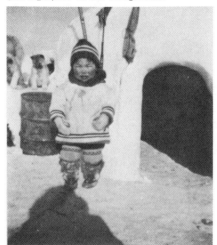

About the story

This book is built around a manuscript written in Eskimo syllabics by Peter Pitseolak of Cape Dorset on Baffin Island when he was 71 years old. It arrived, a marvelous surprise, in a mailing tube in my mailbox in Montreal in the summer of 1972.

Peter Pitseolak and I had first met the year before while I was in Cape Dorset collecting biographical material on the remarkable graphic artists of this Hudson Strait community. With interpreter Pia Pootoogook I went to see him to ask his help in making a family tree showing the relationships of some of the artists. He immediately produced two booklets in which he kept in neat syllabics Cape Dorset's vital statistics. "These are old and wise notebooks," he remarked. He had been keeping the notebooks, he told me, for many years, since he was a young man. I had no idea he was also writing a history of his people.

As soon as Peter Pitseolak's story arrived in the south, an exciting period of collaboration began. First, the manuscript was translated by Ann Hanson of Frobisher Bay — no easy task since the manuscript was filled with what Ann described as "beautiful sentences," words and constructions that today would most probably be labelled "archaic" Eskimo. Fewer and fewer people know their meaning. Next, after discussion it was decided we should try to fill out the manuscript with more stories of what Peter Pitseolak called the "old Eskimo ways we had" which he feared in a few years would be forgotten. "The people in the world should learn about them," he said, "because the Eskimo language is disappearing."

The resulting supporting narrative, a reportage using the direct quote only and presented here in italics, is taken from well over 150 hours of intensive interviewing. These question-and-answer sessions, made possible by a Canada Council grant, were held on Baffin Island during the spring of 1973. The interpreter for the first concentrated week of interviews which took place in Frobisher Bay was Ann Hanson; when she had to go to work in the Paramount movie version of "The White Dawn," James Houston's novel based on the life of Etidluie, Peter Pitseolak's grandfather (Etidluie's story also is told here), we moved to Peter Pitseolak's clapboard bungalow in Cape Dorset. Here his great-nephew, Udjualuk Etidluie, acted as interpreter for the majority of the interviews which were conducted over a three-week period. Important information also was gathered with the help of Letia Parr, a great-niece, and Annie Manning, Peter Pitseolak's granddaughter. In addition, anecdotal material has been drawn from interviews done in 1971 and '72 with the help of Pia Pootoogook, another great-niece, and Sapa Aliqu. Some material has also been taken from letters written with

Kooyoo, second daughter of Peter
Pitseolak and wife of Kovianaktilliak
Ottochie, with her daughter Mary.

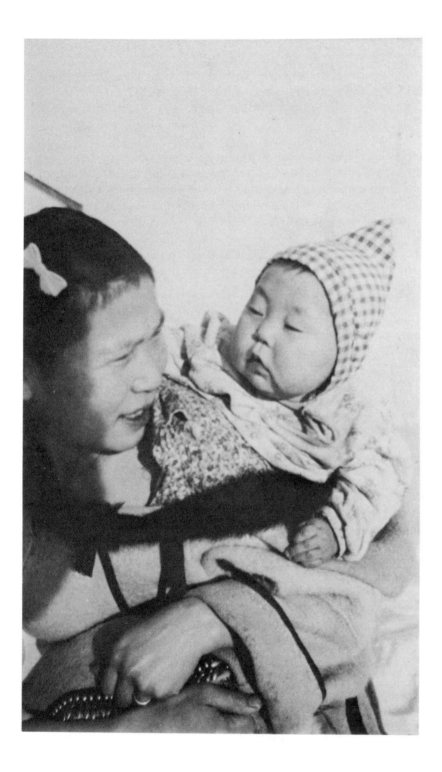

Udluriak, eldest daughter of Peter Pitseolak. She is caught by the camera in a white man's nightdress in the newly finished house built by Peter Pitseolak from lumber salvaged from the "Nascopie."

Mary Pitseolak, natural daughter of Peter Pitseolak, in front of the quarmak – a tent-hut – in Keatuk camp.

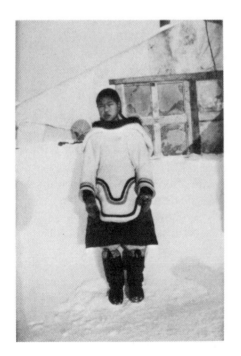

the help of grandchildren and sent to me in the south in response to questions.

With the exception of some short exchanges and the material dealing with the last Tooniks, the earlier Eskimo people, which I wrote up immediately from full notes, interviews were tape-recorded. All interpretation was what translators call "consecutive." This was of necessity since equipment was the simplest and the circumstances comfortable and friendly: in the background of the tapes is the cheerful chatter of grandchildren, the buzz of skidoos, the clatter of tea mugs and the sound of Peter Pitseolak's chiming clocks. To obtain "simultaneous" translation, large sections of the tapes were played back and interpreted a second time while I took the material down on a typewriter. In general, two interpreters worked on each tape. For assistance with translation problems that followed me back to Montreal, I am indebted to Eva Keleotak Deer of Montreal and Jimmy Patsauq Naumealuk of the Northwest Territories Interpreter Corps.

In interpolating Peter Pitseolak's writing with reportage drawn from the interviews, I have tried never to distort his words or intention. Peter Pitseolak himself made small corrections to his original manuscript, writing them into the margin of a photostat copy while we were doing the interviews. In addition, some paragraphs which appeared repetitive have been dropped but no part of his story has been altered. It appears here in translation exactly as he wrote it.

As everyone knows, there is a great tradition of story telling among the Inuit – the 'only people,' as Eskimos call themselves. Peter Pitseolak loved and could tell well all the old stories of how the world was created, of birds turning into people, of animals acting like humans. They were told – sometimes sung – in versions that differed just a little from camp to camp "to make people happy" and Peter Pitseolak described them as "the nicest stories I ever heard." Here, however, he tells stories of a different kind. This book aims to tell in Peter Pitseolak's written and spoken words how things used to be, and also how, over one lifetime, the forces of change – the missionaries, the traders, the law, the government, schools and alcohol – came to Baffin Island. Naturally, Peter Pitseolak's views are his own and neither his fellow countrymen nor white people who know the North are likely to agree with him all the time.

Peter Pitseolak with the 122. This camera was given to Peter Pitseolak probably in 1946 by his nephew Salamonie who received it from the Catholic missionary.

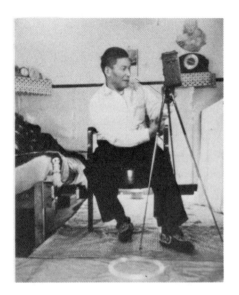

About the photographs

Peter Pitseolak took his first picture in the 1930s for a white man who was scared to approach a polar bear. Peter Pitseolak wasn't sure it was such a safe idea either and he said to a fellow hunter, "If he starts to move, you may shoot him." But he got the picture and in the early '40s, while working for the Baffin Trading Company, which arrived as competition for the Hudson's Bay Company in Cape Dorset in 1939, he acquired his own camera.

"My first camera was a box," Peter Pitseolak told me one day. "It was simple to use; you didn't have to set it. Then I got a camera from the Catholic missionary. It was a 122 camera and very heavy. It was a big one. It had settings that could focus on the subject so you could be sure the picture would not be lopsided. When the pictures were taken properly, they turned out very well. Another camera I got from the Bay manager. It was able to expand. It wore out so I took the good parts and used them with the 122. Later my daughter Udluriak got a 620 and I used that sometimes, too. The only hard part was developing the first pictures. I watched a man doing it but I knew he wasn't doing it well. He was a white man but he couldn't develop pictures. I thought to myself, this man is not washing the pictures enough. So I washed the pictures longer than he did. People often came to me to learn developing – especially the Catholic missionary. He thought he knew how but he was using boiling water! Once someone gave me a thermometer to test the water but my finger was always best. I used to order the hypo from the Bay. Today I have a Polaroid but lately I have been thinking of ordering again. I developed a picture just recently in the x-ray fluid up at the nursing station where my nephew, Elee Parr, is working. It came out. It was visible."

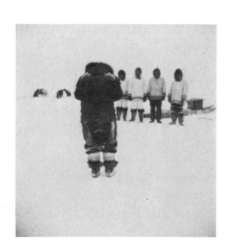

Hunters posing for the camera.

Peter Pitseolak's wife, Aggeok, whom he began to live with in 1941 after the death of Annie, his first wife, was an active collaborator. She became an accomplished developer and printer of negatives and, sometimes, when Peter Pitseolak was part of the picture, she snapped the shutter. (She always says that Peter Pitseolak set the camera.) Quite often he took self-portraits by attaching the string to the shutter – using a file he also made a filter from a pair of dark glasses to cut down arctic sunlight – but a few of the pictures of Peter Pitseolak were taken by his beautiful daughter, Udluriak, who died from a heart attack in 1971.

Particularly interesting descriptions of the techniques they used and the circumstances in which they developed and printed are related by Aggeok. When Peter Pitseolak got his first camera (he thought the year was 1942; Aggeok believes it was 1943), he was living in Cape Dorset and working for the BTC, and a number of the photographs he took at this time were

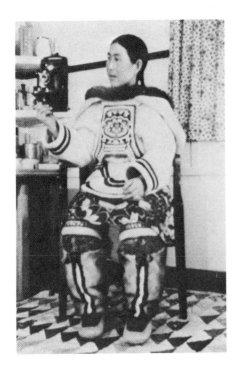

Aggeok with the 122. Taken by Peter Pitseolak with the "box," probably about 1947. She is wearing Peter Pitseolak's boots with the traditional vertical men's stripe. The chair stands on a patchwork quilt.

developed on camping trips in igloos. "When Peter Pitseolak wasn't working we would go out camping for a while," Aggeok says. "When he was out hunting he would put the camera on top of the igloo until the film was all used up [in order not to subject it to temperature changes]. He used caribou skins to wrap it up. He would put it on top of the igloo with the dog traces over it so it wouldn't blow away. Only after he finished the film would he take the camera inside and take out the film. We would develop on top of the sleeping platform. We used a three-battery flashlight and covered it with a piece of red cloth."

Printing the pictures, Aggeok explains, had to be done "where there was light," so the first pictures were printed back in Cape Dorset in their small wooden house which the BTC made available. "To make the prints he would place the negatives with the paper in this 'tagatujuk' [literally, 'like a mirror,' but in this instance, a print frame], which had locks that unlocked and a part would open where you put the negative and the paper making sure the paper was the right way. Then you would lock it and once that was done you would place it in front of the lamp, which hung from the ceiling, counting 'One, two. . . .' You would make sure you kept it there long enough because depending on the time, the lightness or darkness of the prints would differ." How did they feel when they printed their first pictures? Aggeok says, "We were laughing; we were happy and we were proud."

In 1946 Peter Pitseolak ceased full time work for the traders in Cape Dorset and moved a few miles away to Keatuk where ten families lived under his leadership. Keatuk was to be his last camp; he left it for settlement life in 1961 when his adopted daughter Annie had to go to school. At that time there were still a dozen permanent camps in the Cape Dorset area. However, erosion of the camp system began, Peter Pitseolak tells us, with the coming of the teachers and government in the '50s. The Canadian government's decision in 1965 to replace snow houses, tents and shacks in the settlements with permanent housing, delivered a death blow. In 1970 one permanent camp remained in the Cape Dorset region; in 1971 it, too, was gone. In Keatuk camp developing and printing were done in the family's hut, built partially from lumber salvaged from the wreck of the HBC ship "Nascopie" — as a dwelling place the hut was never a complete success since it could not easily be heated — and in the 'quarmak,' a double tent set over a wooden frame, lined with bushes and banked with snow blocks. Many of the pictures from this period are portraits taken prior to Peter Pitseolak's evacuation in the early '50s for TB, a time when Aggeok says he would take pictures only "when he didn't have to move around too much."

One often-asked question is whether Peter Pitseolak knew he was photographing a disappearing life style. The answer is that he was well

Peter Pitseolak liked to experiment when printing negatives. Here he created a composite picture from two negatives sandwiched together. Syllabic translation: A portrait of Peter Pitseolak at age 46. Photographed by his wife with only the light of an oil lamp.

Peter Pitseolak usually got a good reaction when he showed lower left photograph to friends and remarked, "All those men want to get that woman." He has printed himself on both sides of the central family picture.

A diamond-shaped print of Mark Tapungai.

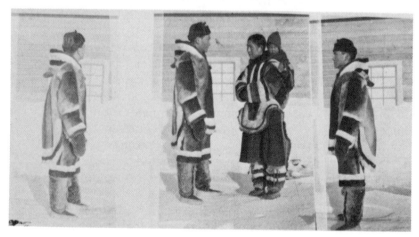

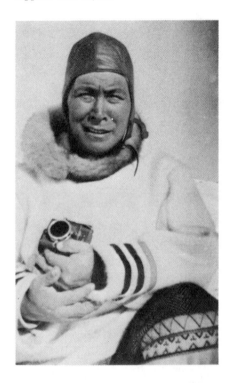

aware he was documenting vanishing Eskimo life, although he considered his work was for the benefit of his grandchildren. Many pictures were set up specifically for the camera to "show how for the future."

An important reason for many of the posed photographs was to help Peter Pitseolak with his drawings. In the 1950s, as the traditional Eskimo life style foundered under the impact of the white technological society's northward push, art projects were introduced in the North and supported with Canadian government backing. Particularly spectacular work has come from Cape Dorset and its West Baffin Eskimo Co-operative, owned and operated by the Eskimo. As soon as experiments in print-making got under way in Cape Dorset, Peter Pitseolak began to contribute skillful and vivid drawings that, like his photographs, document Eskimo life.

Today Peter Pitseolak's negatives – some 2000 – are in the Notman Archives of McGill University's McCord Museum. They date chiefly from the '40s and '50s although a few are as late as 1967. The most frequent subjects are members of the family: Udluriak and Kooyoo, Peter Pitseolak's daughters by his first wife, Annie; his natural daughter, Mary, by Nyla of Lake Harbour; Ashevak, Aggeok's son from her first marriage, and his wife, Mary; and the adopted children and the grandchildren. There are also many pictures of the Keatuk campers and of other relatives and friends. "When Peter Pitseolak got his camera," his half sister Eleeshushee remarked, "the skin clothing was just beginning to disappear – many people borrowed my clothing to dress up for his camera." Since surnames became general only in 1970 when their adoption was officially encouraged, identification is often by a single name.

They are, of course, pictures taken by an amateur – the prints were glued into a family album. Although the best pictures display a high degree of skill, perhaps their great value lies in that they were taken by the photographer for his own delight. For like all amateurs with a camera, Peter Pitseolak photographed the people around him and their everyday life. In doing so he photographed an era – a period when people still got their food from the land, but when camp bosses sometimes put up small wooden houses in their camps, when planes made mercy flights, and when, eventually, a plastic igloo went up in Cape Dorset.

Peter Pitseolak's camera caught, as no white photographer's could, intimations of change, and the final moment of Eskimo camp life.

Dorothy Harley Eber

Montreal

Seekooseelak, the coast 'where there is
no ice' in late spring.

Before I was born

My grandfather's journey
Killing the white men
What shamans could do
Meeting the last Tooniks
Hunting the old way
Taming the caribou
Celebrations in the giant igloo
The first religious time

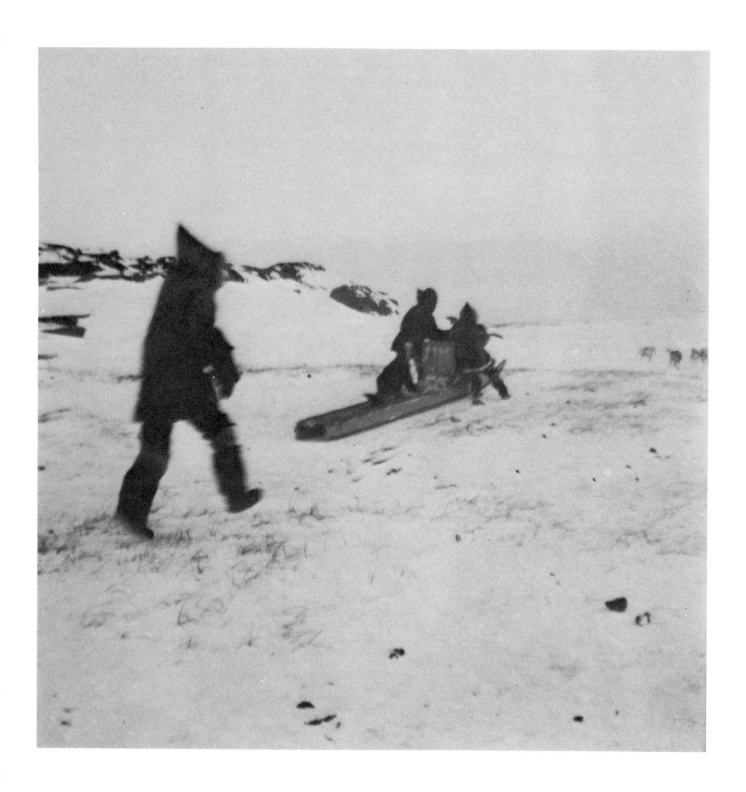

A long time ago near Cape Dorset there was a special 'inukshuk' and in the old days the people from our side who were going to cross over used to go to the inukshuk* to give presents.

They would say, "I give you this. I wish to return again." Of course sometimes they died.

But you didn't need to go right across the Hudson Strait to Arctic Quebec to give gifts to the inukshuk. Once my mother's sister was going only to the Akudluk Island. She gave one of her bootstraps. I said to her, "Is that all? That's not very much!" She got mad!

You can still see the stones of this inukshuk here near Cape Dorset – which we call Kingnait. Just recently people found beads and some bullets there.

We used to say that the people who crossed to the other side in the sealskin boats were "very willing." They were willing to go though they had only oars and the sail from intestine. They had a long way to go but the weather was always good in those days. They were stronger than we because they worked harder, and they crossed through the Toojak Islands – Mill Island which we call the little Toojak, Akudluk Island, which means 'in the middle' and which the white men call Salisbury Island, and Toojak or the greater Toojak which is Nottingham Island. We used to say people who crossed other ways would have shorter lives than those who crossed through the Toojak. In Inuit, Toojak is a safety guideline; it means 'because of these islands we are alive.' There are many Toojak.

I have always strongly believed that my grandfather Etidluie was born here in Baffin Island. I believe it because he had many cousins on our side. His first wife was Atsutoongwa but he didn't have any children, only a stepson. Later he had another wife, Ekahalook. I think he went to Quebec before he had children but I'm not sure. But when he was a young man, perhaps when his first son, Kiakshuk, was already born, he crossed over to Fort Chimo in Arctic Quebec and worked for the first white traders.

The 'kadluna' – the white men – had gone first to Fort Chimo and my father, Inukjuarjuk, was born when my grandfather was working there. As a baby my father was taken by Indians. He was changed for a little Indian boy. Etidluie was away hunting for a month – he used to stay out a long time – and my grandmother was too frightened of the Indian people to say no. She gave her son to the Indians and got a small Indian back. When Etidluie came home he probably got mad for, without even sleeping with

*A cairn, built as a marker, a direction indicator, or for herding the caribou.

19

his family for a night, he put the little Indian in a box and carrying him on his back went to get his son.

In those days Indians were dangerous for Eskimos. They used to kill people. They used to play tricks with the Eskimos' traps. One Indian did a shit on a trap and the trap jumped up and caught his penis. That Indian died. But my grandfather was not afraid of Indians. He used to sleep with Indians. He was the only man who was not afraid to be with Indians.

The Indian woman who had my father could speak some Eskimo. Etidluie found her singing a song in Eskimo to the baby. In 1926 I went for the first time to Fort Chimo and my old aunt Piyourik sang me the song. For years after they had been imitating the way the Indian woman had sung the song:

*This little boy will bring me food
From the stores of the white men,
This little boy will bring me food.
This little boy will bring me food —
He brings me food.*

The woman wanted to keep the little Eskimo boy because she thought she would get white men's food through him. Etidluie used to be given food where he worked but Indians could only get kadluna food through trading.

When my father, Inukjuarjuk, was still not old enough to row, Etidluie made an 'umiak' — a sealskin boat — near Fort Chimo and came with it along the coast. I remember the boat well. It was huge. I used to jump up and down in it as a boy although they told me to stop. We always used it until the Hudson's Bay Company came to Cape Dorset. The skin boats were used until that time although we had wooden boats. In the end it was left behind in our camp at Ikirassak. It just rotted away down there.

I don't know who the women were who sewed the boat. My grandmother Ekahalook had already died. Etidluie's two daughters who remained in Arctic Quebec may have helped. The boat was even bigger when my grandfather planned it but it was using too many skins and he had to reduce it. They were saving skins all winter. They had a mast made of log and a sail made of strong cloth. Since Etidluie had only his sons to help him row along the coast, he made special helpers for the oars. He tied the oars to the oarlocks with twisted ropes which caused them to spring back. The oars were very heavy. The ropes were also tied round the bodies of my father, Inukjuarjuk, and his brothers to keep them from falling out of the sealskin boat.

*When they reached the land between Cape Smith and Ivugivik, they stayed
there for perhaps two winters. It was there they came upon white men's
tracks when Etidluie's sons, Kiakshuk, Kavavow and Inukjuarjuk, and his
son-in-law, the husband of Pulanigiak, were out hunting for polar bear. My
father, Inukjuarjuk, told me this story; it happened somewhere between
Cape Smith and Ivugivik where there are many polar bear.*

*My grandfather Etidluie didn't go out with his sons and the husband of his
daughter; he stayed at home in camp – he was already old. The boys found
tracks. When they saw the tracks they didn't examine them closely – they
thought they were caribou tracks, there were so many. They followed.
The tracks led to the mainland from the salt sea. As Kiakshuk, Kavavow,
their brother-in-law, and my father – he was still a very young boy – fol-
lowed the tracks, they got fresher and they turned out to be white men's
tracks. They began to find things the white men had dropped: biscuits,
clothing, other things. The white men were tiring. Each time the boys saw
something dropped by the kadluna, they tried to beat each other picking it
up. As soon as they saw something, everyone ran.*

*They found a spot beside a giant rock where the white men had stopped to
shelter. The white men were not able to build snow houses so they had slept
outside. The places where their bodies had rested had become icy. They
followed and followed the traces until it was dark and the moon came up.
Then in the snow ahead they saw a dot. It was black and quiet. They knew
it wasn't a rock. The dogs went faster and faster. When they arrived,
the boys drew back in horror. They found a dead white man. He was facing
down and the body was not yet frozen.*

*The boys talked among themselves. They thought they would find dead
kadluna again and again. They were all so young and they were afraid.
They turned round and went home. When they arrived it was midnight and
Etidluie was asleep. To see what he would say, they threw some kadluna
boots into the igloo. They didn't say a word. But Etidluie made a great
noise. He shouted, "Heeayee!" – the old Eskimo way of saying thank you.
He said, "It will be good to have some tobacco." He had been with white
people and he liked to smoke.*

*When they got inside, they told everything that had happened. Etidluie was
angry with the boys for returning before they had found the white men.
"You knew the tracks were fresh," he said. "You might have saved lives.
Kadluna are not dangerous. Why were you afraid?"*

*But they could not go back right away. The weather was bad so they could
not move. When it cleared, Etidluie went too but, because of the storm, he*

knew the white men who made the tracks were dead. So he followed the tracks backwards in the direction from which they came.

They found the kadluna staying in a Peterhead which belonged to their large ship that had been lost. One of them must have heard the dog team approaching. He came out to look for them and then the rest followed. Etidluie said, "Chimo!" and the kadluna said the same thing. By hand motion the white men told them to come on board. They were very hospitable.

I can't remember how many kadluna my father said there were — maybe four, I'm not sure. They were the bosses of the ship. (Later it was heard that the captain had thought, "If all the people stay there will not be food for us." He was selfish. He told the crew to go away.) By hand motion the ship's boss told the Inuit that they should move their camp near the ship and help. Etidluie and his sons didn't understand his words but they could understand what was wanted. The boss said where they should build the igloos and he gave presents. By sign language he said he would give more.

So they moved to that place and started working for the white men. Kiakshuk was a real worker and he got more things than anyone else. He was given four boxes full of stuff.

Other Eskimos found the camp. Suddenly there were lots of people in the camp. More came all the time.

These people who arrived were crazy with jealousy. In those days the people were already beginning to get less intelligent, less smart. All they cared about were possessions. These people who arrived were not working for the white men so naturally they had not received anything. They decided to kill the white men; then they would be rich with all their possessions.

There's a story that Nanualuk became boss and wanted to kill these people. Saggiak here in Cape Dorset has a different name — Pavik. Saggiak and I both know this story though our stories may not be exactly the same. I have heard, too, that the Inuit decided to kill because the white men were taking the women. I think this is wrong. My father told me they decided to kill because they wanted the white men's things.

Those who wanted to kill had a woman make mitts without thumbs which had long arms. The skins were not to be softened so that those who wore them could not pick up weapons. They were to have laces so that they could not be pulled off.

When the mitts were finished the killers went to see Etidluie and said, "There's going to be fighting. If you and your sons do not help kill the kadluna, you also will die."

Etidluie replied, "Taigalook! — how disgusting!" It's a word from the northern Quebec people. Etidluie was silent for a minute from shock. He wanted to think.

Then he spoke and this is what Etidluie said: "For myself I am not possessive about my life. But for my sons, if one of them has life still to live, I do not want him to rush to death. I do not want him to die of wounds. So let them help you, for though it is very sad, none of us can live forever."

Etidluie said to his sons, "You must be among the helpers. You must be ready when the leaders say, 'Atai' — let's go! I am very sad that this has to happen. I act as if I want you to do this thing. I do so because I want you to have life."

Etidluie didn't help with the killings; he had liked those white men.

I am not boastful about my grandfather; he died before I was born — but he was a very good man. He may have been without God in his life but maybe God was his teacher. That is what the minister used to tell me.

The killers took the mittens with them into the house of the white men. They helped the kadluna put on the mittens and they seemed to be very friendly people. When the mitts were on they tied the laces. Those mittens had no thumbs; no one could pick up his weapon. Then someone shouted, 'Atai,' and the others entered the house.

One kadluna was very strong. He punched off the killers and knocked them down. He ran out of the house without a wound. The other kadluna were killed in the house.

Kiakshuk and Inukjuarjuk followed the white man. Kiakshuk caught him first. He was a very fast runner. My father used to tell that he reached the kadluna after his brother and the man was repeating, "Suvitit, suvitit? — what are you doing?" He must have wondered why they were doing these things because they had been friends. My father used to say that he had liked this man very much.

There was a man picked to do the killing but he came late so Kiakshuk was holding the white man. He needed help so my father held, too. Kiakshuk told Inukjuarjuk to hold the arm and the kadluna asked, "Suvitit?" They

Seal hunting camp near the floe edge.

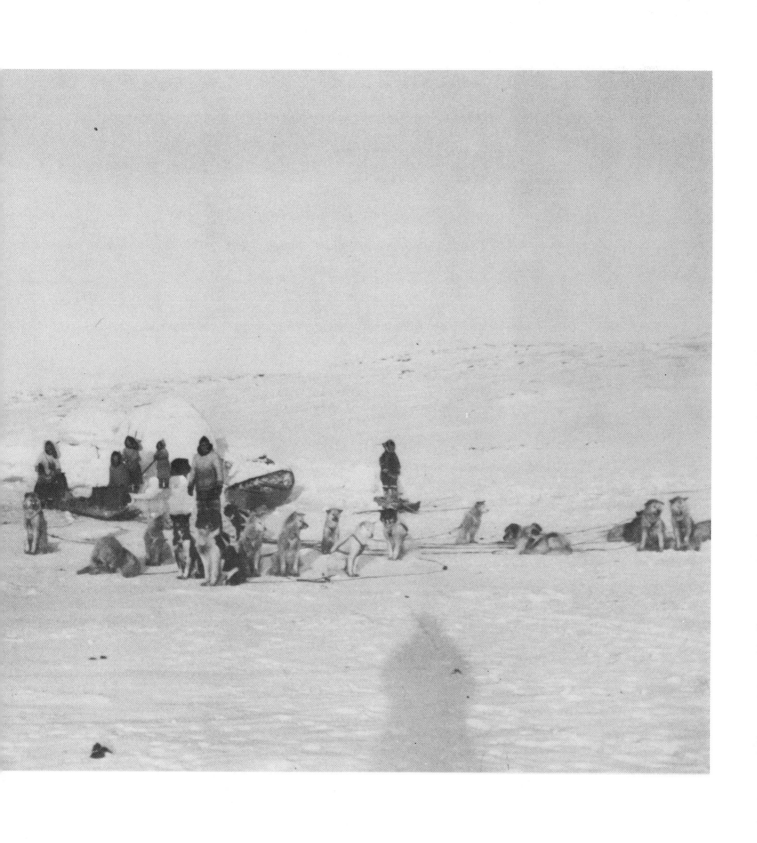

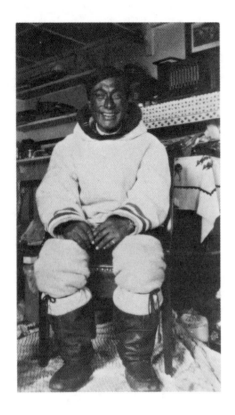

Kavavow, Inukjuarjuk's son by Kow-madjuk, his fourth wife. He died about 1969 in Frobisher Bay.

didn't answer. Then the kadluna just looked out into space with wide-open eyes. He looked without blinking. He didn't say anything at all.

The killer came. He drove the knife into him and the kadluna was dead. Inukjuarjuk had a small knife because he had been told he should have one. When the kadluna was just about to die he put the blade into the wound a little bit so the people would think that he had helped. He didn't want to be killed by the killers.

I have not heard that the other two brothers did any killing.

After the killing, they went back home. Then somebody came to their house. This man was unhappy. Of course he wanted a box. This man was Nanualuk. Kiakshuk went to him and said, "I helped you. What do you want with this? You did something we did not want to do. Leave that alone."

Nanualuk fell down from fright. He just lay on the floor. Maybe he thought he would be killed.

All those people who killed were given a mark. They were tattooed on the bridge of the nose — because they had killed kadluna. They used to tattoo the men when they got something big.

My father had his mark with him all his life.

After a while one of the men who had been involved in the killings went to trade, maybe to Chimo. Since he was marked, it was known who he was. The white men took hold of Axaganyu, the woman with him, and said, "This is the woman who made those mittens." They put her up on the roof and the men had rifles to shoot her. Then a man came along and said, "It's not her, it's not her. You've got the wrong woman."

She was on a wife exchange.

Etidluie and his family were back in Baffin Island when they heard this story but my father had known Axaganyu. He used to say, "I can see Axaganyu now with those small eyes of hers sitting on the roof waiting to be shot."

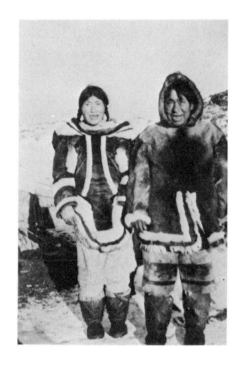

Parr and Eleeshushee, daughter of Inuk-
juarjuk by his second wife, Kreemipikulu.

But Etidluie did not come to our side because of the killings. He came to
get married again. He had heard that his old girl friend, Alenga, didn't
have her husband, Niviaksiapik – he had died. Etidluie had been with Alenga
once on a wife exchange. Before Etidluie went to Arctic Quebec Niviak-
siapik used to borrow Atsutoongwa. That was the custom. Nobody minded
– unless people were sneaky about it. If a man felt jealous, he would say to
himself, "I am just as bad as they," and try to cure himself of being jealous.

I've heard only the immediate family came with Etidluie along the coast
of Arctic Quebec. But I don't know how many made the crossing.

In those days they had the shamans and the shamans had a way of arriving.
People were not allowed to step on the land before they said their saying.
At the time it was the custom. Everybody did it. Every time they got to
land – if it were not the land where they lived – they would not walk, only
crawl, to the shore. They would crawl to the point the high tide had
reached, and they would sing as they crawled: "This giant land, I am
stepping on it! Appapapapapapapaa!"

If a person was a stranger, the land had a way of ignoring him if he didn't
say what had to be said. People believed if they walked they would not
reach Baffin Island again.

It could be embarrassing – singing this "appapapapapapapaa!" if I weren't
telling a story about my grandfather!

I often think there was a shaman with them in the boat on their journeys
but I don't know who. It wasn't Etidluie or his family. Etidluie used to tell
his children not to follow the shamans because they were meaningless.

I was born when the "appapapapapapaa!" was no longer sung. It was, but
people were more or less hiding it. Okhamuk – Rev. E. J. Peck, the very
first minister to teach the Eskimo people – had told them not to use it any
more. Because Reverend Peck could talk so well in Eskimo we called him
Okhamuk – 'the one who talks so much.'

Before I was born there were so many shamans. They had their helpers of
course. They could make helpers from any kind of animal, from worms, bugs
and the spirits of dead people. The good shamans maybe were Gods. A long
time ago they could cure people's sickness.

When I was born there were not obvious shamans – Okhamuk had told
them to repent – but they were still sneaking around behind Okhamuk's
back. Aggeok's grandmother used to fly in the air; Parr's mother used to

27

Alariak and Allego, both important
shamans in the Cape Dorset area.

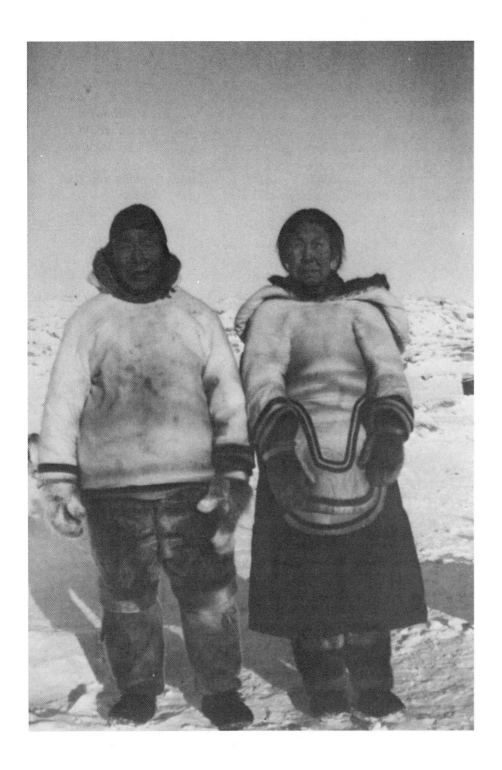

jump on a harpoon to fly. One man had three marks on his cheek for killing ghosts: he fought a ghost round and round a rock and killed the ghost with his shaman's spirit. Another shaman had a handful of little crows for spirits. Elee and Suka said, "Show us your spirit," and saw little small crows jumping round on the shaman's palm.

I've known so many shamans and know so many stories. I can imitate shamans. I've even got photographs of shamans.

But I don't like shamans. Even the good shamans belonged to the devil. I've heard many times of the things they could do but since I've been old enough to understand things, I've never seen real shaman work.

Etidluie told his children not to believe in shamans. He told them not to believe in ghosts because they didn't exist. And he said, "Don't be scared of the animals. If they are going to die, that's the end of them." He said it's always the same world – in light or dark.

He was often tested. But in all his long life there was only one time when he was half afraid. He had found an old whale on the ground and the foxes were eating from it. He set up his camp by the whale and all night long he was catching foxes. Then, although the whale was frozen, he saw it breathe – he saw it breathing twice. He was almost afraid then but he went to his igloo and walked around because he was nervous. He said, "I am being foolish – there is nothing here." So he stayed on and was no longer afraid.

Etidluie was a good man to anyone who came around. The only people he didn't like were the shamans. He was kind to everyone, no matter of what race. Yes, at that time, some didn't like the white people – or the Indians. I've heard bad things about other members of my family – but never about my grandfather. He was always in a good mood – never angry.

The only problem he had was that he couldn't run. He only walked very fast. Nobody knew why; that was his way.

Etidluie stayed in Seekooseelak because he liked it here. It's not the name of one camp or place – all around Cape Dorset, that's Seekooseelak. It means 'no ice'; there is no ice at break-up. Other places have a great deal.

Seekooseelak used to have many more animals than the Lake Harbour area. Many walrus. And more polar bears.

To me it's always been best.

Nuvoojuak people. Two pictures taken
by Peter Pitseolak when his dog team
crossed those of Nuvoojuak people on
their way to better hunting. Top, right
to left: Ragee, camp boss, his wife
Staralaq, Akitee, her husband Reeluajuk.

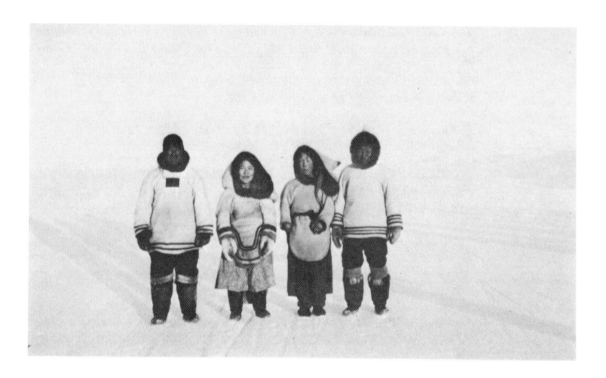

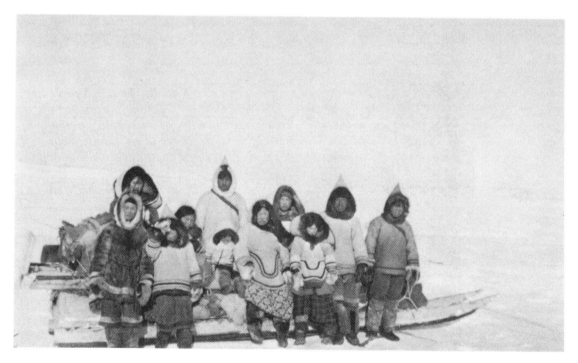

My father used to say that when Etidluie came back from Arctic Quebec to Alenga it was as if they had been together for years. He had come home.

He came from our side for sure.

I do not know when Seekooseelak began to have people. As far as I know there were always people in the different areas. There were always people who belonged.

In the Cape Dorset area there are many graves of the Tooniks — the early people. They are usually by the shore — they're all over the place if you really look. The Tooniks were very short and very strong people and their graves were shorter than ordinary Eskimo graves. When the Tooniks were still alive they had a different way of burying their dead. They covered them over with stones. Until the ministers came the ordinary Eskimo people just put stones around the body.

I have seen very few Toonik graves that still had everything in them. Some of the bones had been taken away by animals. What was left was usually the skull. The skull was normal but the bones were large — shorter than ordinary Eskimo bones but wider. At Keatuk, my last camp, there is a very large, giant grave. I have always wondered what was buried there.

The Tooniks lived in giant houses that were made of stone. I have seen unbroken giant houses on Coats Island. We used to see them when we were passing by. You could even see the doors. Up to today if you touch the stones you still get soot on your fingers.

From Kingwatsiak I heard the story of what happened when our people met the last Tooniks. It happened before I was born. I am really sorry King-watsiak died before I had a tape recorder because he had amazing stories and a very good voice. He was old enough to be my father and when he was a young man, before he was married, he went to Scotland on a whaler. He was my distant cousin — our parents had been closer relatives. When they died, my father and Kingwatsiak were the oldest people I ever knew.*

*The Tooniks, or the people of the Dorset culture, lived in Baffin Island until about 1300 AD when they were engulfed by new Eskimo people arriving from the west. Noah Nuna, Peter Pitseolak's cousin, says that according to legend a great battle ensued and only one Toonik man survived. He and his family left Baffin Island in their sealskin boat. Scholars still debate the identity of the people Kingwatsiak met at the turn of the century on Southampton Island when the "Active," with Alexander Murray as captain and his brother John Murray as first mate, was cruising in the Hudson Strait.

Peter Aningmiuq, chief of Kudlusigvik
and son of one of the first Eskimo pilots.
About 1947.

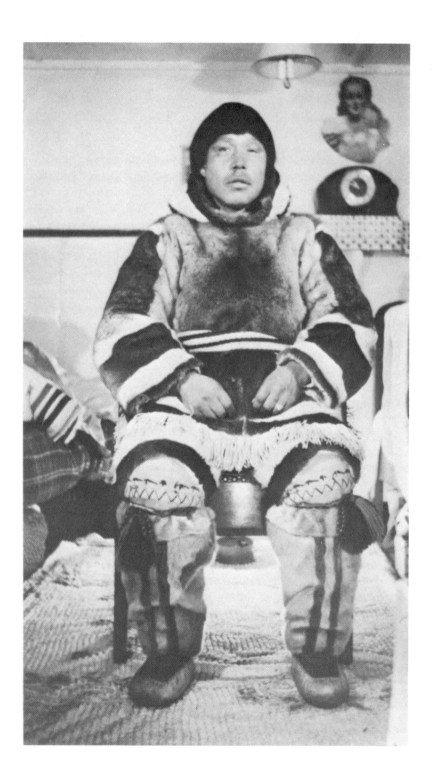

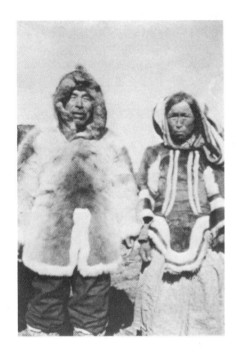

Aningmiuq Seegoaigh, father of Peter
Aningmiuq, and one of his wives, Nakutalia.
Aningmiuq was a famed hunter who killed
three whales while hunting with the
"Active." In the early '30s he regularly
piloted the "Nascopie" through the islands
into Kamadjuak, the HBC post midway
between Cape Dorset and Lake Harbour.

*Kingwatsiak was on the whaler, "Active," when it contacted the people of
Southampton Island. I heard from Kingwatsiak these people were talking
like small babies, unable to pronounce correctly. And they were very, very
messy with their animal flesh. They didn't clean themselves. We called
them the 'Pujite,' which means 'dried-up oil.' All the oil and blubber was
caked into them. When they were first approached by the "Active" they
seemed very afraid and would not come out of doors. Then one came and
said, "Are you harmful?" They were answered, "No, we are harmless."
Then they said, "They are harmless, let's go and see them." After this they
were friendly to each other.*

*It was the first time the people from our side had ever seen them. These
messy people were very strong. They had two chiefs — Kamakowjuk, the first
chief, and his brother, Avalak, the second chief, who was seen to carry
a very large rock in his arms up from the shore. There were many people.*

*Years before, people from our side used to go across to Southampton Island
in their skin boats using the inukshuks at Inukshuk Point as guides. At
that time people from our side called the Pujite, 'Takoogatarak,' meaning
'we are shy with them,' because even before the skin boats got to shore the
men there would try to trade wives with them. Then they'd say in their baby
voices, "They don't want it, they don't want it." But before the "Active"
reached them, nobody had been to them for years.*

*The Pujite asked the Eskimos if they were able to eat raw meat and the
Eskimo people said yes. So a Pujat called Napeegak and Kingwatsiak went
to fetch the meat together. It was cached under a rock. Kingwatsiak and
Napeegak were nervous of each other. Napeegak had great strength and
Kingwatsiak had a very sharp knife. Napeegak asked for the knife but
Kingwatsiak didn't give it to him. They didn't trust each other.*

*Kingwatsiak never said these people were short; he often said they were
ordinary looking men — but he thought they were Tooniks. The principal
difference was their messiness: they had great strength and they were not
very careful with blubber. When asked if they were Tooniks they said in
their baby voices, "We have only heard of Tooniks; we are not Tooniks."
But they were the only people who talked that way. The people from this
side didn't believe them. They don't believe them even today.*

*Captain Murray, the captain of the "Active," was really amazed by the
tools the people had — everything was made from rocks. He asked
Kamakowjuk to make a tool while he watched. Kamakowjuk called out,
"Sister-in-law, please bring my 'abbik,' " — the sealskin hand protector. He
called it in his dialect a 'nakootik' and he put a flint rock in the nakootik*

33

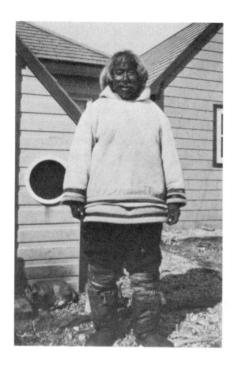

Kingwatsiak. As a boy he went to London on a whaler. His death in his eighties resulted from fire that broke out in his plastic igloo.

and took up an 'eetook' — the polar bear's last rib. With the polar bear stick he started to make a tool. It had nothing sharp but, all of a sudden, it was done. He had finished this very hard rock in no time at all. He had made a tip for his harpoon. It would have been finished quicker but Captain Murray kept saying, "Stop a minute, stop a minute." They collected many of their things.

While the "Active" was anchored people could hear the Pujite being very, very happy. People from our side thought they were happy because they could now get white men's things. Avalak got himself a harpoon like the regular Eskimo harpoons. "The whale dies before I even drive the harpoon into him," he said. He was not used to such very sharp harpoons and he was so strong he would drive the harpoon into the whale and pull it right out again. He was strong!

That winter a great many people from our side went to spend the winter with the Pujite. Captain Murray's brother had wanted to know the best time for whaling and the Pujite had said in the new spring there would be whales all over the place. Pitseolak Oojuseelook was the chief in the Lake Harbour area then and he was very conceited and proud of himself. During the winter Pitseolak and Avalak had a test of strength. Pitseolak just went down immediately and flipped over a couple of times. He got kind of angry and said, "He took me by surprise." He went at Avalak again but Avalak got hold of him and Pitseolak started to have a bloody nose from being squeezed so hard.

There is more. Pitseolak Oojuseelook was a shaman and because he was a shaman people said he killed all the Pujite. Kingwatsiak told me they started dying all of a sudden. Pitseolak was ashamed because he lost in the strength game. People knew for sure, though they never said, that Pitseolak had killed them off. The people from our side didn't die.

After the Southampton Island people died off and there was no one there, the people from this side started to move there. But I know for certain one Pujat survived. One woman moved to Repulse Bay and had a baby after she got there. This man was the last surviving Toonik. Felix Conrad, when he was post manager for the Baffin Trading Company in Cape Dorset, took his picture once up in Repulse Bay. He looked ordinary — his father was an ordinary Eskimo — but in the picture it looked as if he had headphones on. This man told everybody he wanted to learn English so he could buy headphones and listen to the radio.*

*An article entitled "The Mysterious Sadlemuiut," in the winter 1959 issue of *The Beaver*, by Dr. W. E. Taylor, Jr., director of the National Museum of Man, Ottawa carries a photograph, attributed to C. E. Jordan, of Etienne Kingak, perhaps the last Toonik. He died in 1947.

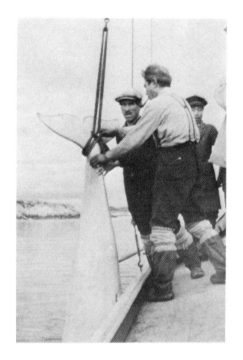

Taking a whale aboard.

I don't remember the name of his mother, the last Toonik woman, but once in Repulse Bay, Enoosik, the great-grandmother of Annie Hanson who is interpreting this story, asked her, "Will you please stay here for a minute?" When she came back the igloo was filled with smoke. Enoosik said, "What are you doing?" and the woman answered, "I am trying to keep warm." She had put too much fuel on the kudluk, and the igloo was covered in soot.

These Pujite were very messy people.

In those days there was nothing in Kingnait, here where Cape Dorset is today. Nobody lived here because of the animals. People didn't want to scare them. In those days people didn't waste. When my father, Inukjuarjuk, used to be the leader there was one special kind of seal he always watched to see that not too many were killed. The best hunter in a camp used to be the leader and my father didn't want anyone to live here in Kingnait because perhaps the animals would go away because of the smell of people. I have often said to the game laws people, "When my father was the government there were so many animals; now that my father is not the government, the animals have gone away." Cape Dorset used to be a hunting ground: it had many walrus, polar bears and seals.

Before I was born Inuit used only harpoons and the bow and arrow. My father always had a rifle because Etidluie had worked in Fort Chimo. Inukjuarjuk and some of his people were the first to have guns. But my father was a very careful man. He had kept the bow and arrow and occasionally used it because of his pride in doing so and also to teach my brothers in case there was no ammunition. He told my brothers always to take along the bow and arrow — just in case. They should use it if necessary. The really poor people had only the bow and arrow. They would go hunting with those who had guns and share the meat with those people.

Those people with the bow and arrow used to hide behind stone blinds. Also, they used the inukshuk. The 'tuktu' — the caribou — thought the inukshuk were real men. If possible the hunters would put moss on the top of the inukshuk so that hair would move in the breeze. Those early people were smart. When there was ice on the lakes the hunters would drive the caribou onto the ice: on the slippery ice it was easy to catch them.

I never hunted with the bow and arrow but I have seen bows and arrows.

Once, after I was born, my father had an accident with the bow and arrow. Perhaps other people would not remember because I was very small —

Peter Pitseolak's skin clothing. Skin
strips sewn to boot sole are to prevent
the wearer slipping.

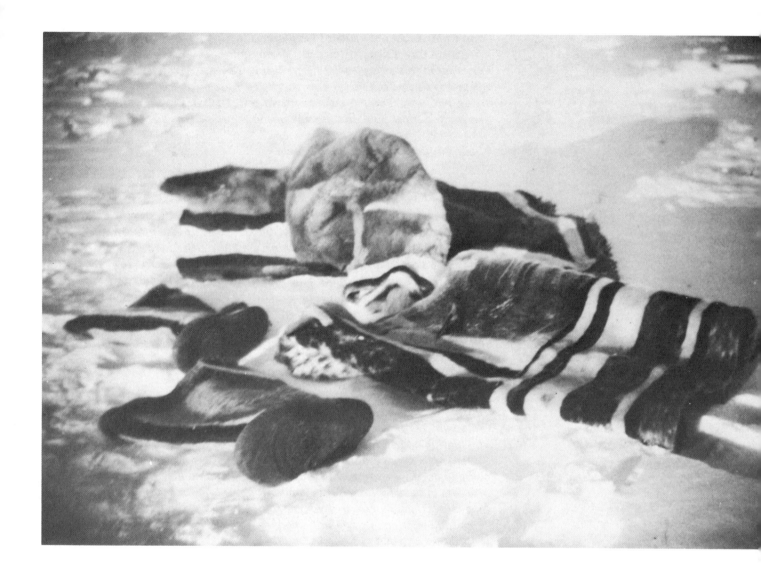

unable to walk — but I remember many things from this time. There were many caribou and I was put on the ground because my mother had to use her parka for waving. The hunters used to wait in front and the women would drive from behind. So my mother put me on the ground and I was screaming. I was helping my mother! I remember I looked into the caribous' eyes — they were so close.

While they killed caribou my older brother was hit by an arrow. My father always shot at the heads of the animals but this time the arrow glanced off and went into my brother Joanasee's arm. They couldn't get it out; they had to call people to help. But then Inukjuarjuk pulled it out. It healed. They probably used the 'pujualik' — the mushrooms. They were very effective. Or they would peel off a thin layer of the caribou skin — it is elastic — and put it on the wound. It would stop bleeding. If somebody had a very bad cut they would call in the 'aloochiuk' — the person who licks. The aloochiuk was a special shaman who put his tongue to the wound. It would stop bleeding but he had to swallow the blood. Otherwise it would start again.

A second time, when I was older, I was standing beside my brother Pootoogook and Pootoogook shot a fat summer caribou with a gun. If Pootoogook had not used the gun my father would have shot it with the bow and arrow. But that caribou Pootoogook shot was still moving a bit. My father gave me the bow and arrow and maybe somebody held my arms to help me. I shot and grazed the caribou. My family told me I was a great hunter.

On the way to Lake Harbour there used to be a camp called Aulassivik — the caribou training ground. It used to be very important. This was a place where they trained caribou. Once there were many 'aulassivik.' Farmers have fences, the Inuit didn't have fences, but they used to keep the caribou in these places. They didn't stay with them all the time; the caribou wouldn't go away. They had been taught. The hunters beat the caribou into an area; they pushed them to a point. Then the hunters would twang the strings of their bows at the caribou until they were used to the Eskimos. Then they'd touch them with their arrows. After this the hunters sang songs to their caribou. It made them trust the hunters.

A man would try to collect a herd. If a caribou was new to the herd he'd be jumpy and nervous. But once they were used to the human they never ran. If a man had trained caribou, no other man could have them. If a man killed one because he was hungry he would take the skin and ask around the camps, "Who owns this caribou?" The hunters would look at the fur and the man who recognized it would take the skin.

No, the shamans had nothing to do with the songs. Singing was just an ordinary hunting method. The Inuit used to make up lots of songs – all kinds of different songs to make it easier to hunt the animals. They sang to get the animals used to the hunters. These early people were very clever. We people now have guns; in the old days people just used their voices. No guitar, though!

I've never seen real caribou training but I've heard about it. My mother used to know the caribou taming well. And I've seen demonstrations. In the old days they didn't know about Christmas but in the very short days they used to have celebrations. They used to build a giant snow house – a 'kagee.' I've seen two kagee; one was large, one not too big. At the time of celebration a lot of people used to sing together. In the large igloo they had a kudluk – a seal oil lamp. The snowblocks were piled up and the kudluk was on top. These people would sing and look at the lighted kudluk. The song would be a hunting song, made by a hunter. Many women would sing along with the men; they had learnt the words.

They would play games – gambling games. One game was Noolootak. They would make a piece of string taut to the ground. In the middle they'd put a piece of ivory with a hole in the centre. People had to try and get a stick in. On the string were tied the teeth of walrus. They were made like beads and made a noise like bells. The sound was fantastic when the people were pushing at the ivory. Whoever hit the hole first was the winner and he got a prize. Just as today we pay to go into the community centre when we go to a movie, these people did the same. They threw their gifts down in the kagee when they arrived.

The winner of the game would lead the song. The winner would stand by the kudluk. The snow blocks were piled up so the height was right for the ordinary man. Those who were taller would look down. An ordinary man would look straight at it.

This song was the personal hunting song of Nuna, my cousin Noah's father:

Over there –
jeeja jeeja
raja ruga
one who has horns!
He is eager to go
his food . . .
he is stepping on it.

*One who is a mother
she is eager to go.
She seems to have borrowed
the big buck's mind.*

*Over there
jeeja jeeja jeeja
jeeja jeeja jeeja jeeja.*

*Also there were acrobatics. Ropes were twisted and attached through the
walls of the igloo with toggles. The rope was quite high; a man couldn't
reach it without jumping. I've seen my father swing on the rope; even when
he was old he used to do it. Once my uncle Kiakshuk went in a sealskin
boat and Inukjuarjuk in his wooden boat to play games with the people in
Arctic Quebec. The people from Baffin Island won everything. One of my
father's people could cross his arms in his sleeves and fall sideways or
backwards and bounce right up without using his hands. That's why the
Quebec people gave up. Inukjuarjuk asked them for a return match on
Baffin Island but they never showed up.*

*The shamans were there in the kagee and the shamans would perform.
They'd dance and they'd put all the women in the middle and join hands
and go round and round. Then they'd stop and kiss the women — whoever
they wanted to kiss. He who got jealous first when his wife was kissed, he
was out of the game! The game was called 'kiveetuk' — going around.*

*They would wrestle and pull each other and do drum-dancing — 'kilautjoktot.'
I suppose in the giant igloo* some used their magic. It is easy to think so
because I have heard that when the shamans were over-happy the
'toonigak' — the spirits — would come to them. The shamans would imitate
whatever spirits they had in them, the spirits of animals or sometimes the
spirits of dead people.*

*Many years before I was born, when my father was young, a traveller who
was captain of a skin boat crossed from Arctic Quebec and reached Tikerak.
This was Johanasee Igegeejuk's first wife's grandfather. When the boat
landed the people began singing. They didn't realize it but they were
singing a real hymn — a hymn from the hymnbook. They told the people in
Tikerak they were singing a song that belonged to the spirit of the earth.*

*According to Eleeshushee, Peter Pitseolak's half sister, this festival always took place at
the time of the full moon.

These people didn't know God. They had probably heard about him but they had forgotten. They had got their song, they said, from the spirit of the earth!

I was born when Christianity had already come to Baffin Island. For myself, I did not like the old, old way because the shamans would kill the people they did not like. When the ministers came the shamans stopped their killings. Reverend Peck — Okhamuk — was the first minister to bring the word of God to Baffin Island. People were very fond of him because he was so loving with all the people and very friendly.

Even before I was able to talk I had learned all the alphabet songs by listening to people sing them. Okhamuk taught the people the alphabets by singing. When the government had come to the North and they were handing out these papers with the Eskimo alphabet and the English alphabet, a man came and said, "You have to learn these." I told him, "I knew them before I could talk." He said, "You can't possibly know these," and I said, "What do you want me to do? Close my eyes and sing them to you?" He was very surprised that I knew them in both languages. He said, "So you have learned."

But at that time, when the people were changing, they believed the wrong things. They were so mixed up they overdid their religion. The first religious time took place in 1901, the year before I was born. When you tell a story about these people who were overdoing their religion it sounds as if they were all drunk. They were blind to what they were doing.

I'll start at the beginning. Simigak was out hunting one night, sitting by the seal hole waiting for a seal to come up. All of a sudden he saw Jesus coming down to watch him. He thought it was Jesus but he was mistaken; it was Satan. When he returned home he told the people he had seen Jesus. Then Simigak said, "We must get together, everybody must get together," and they all went to a place near Cape Dorset called Tooneen. There they built a giant igloo for a church. It had no roof so they could see the Heavens.

Simigak was the chief in the Etidliajuk area — I've heard he was the tallest man in Seekooseelak — and he was in charge. But when they gathered in the big new church, Simigak's cousin, Keegak, was outdoing everyone with the ceremony. In that church the leadership passed to Keegak — 'the messenger,' that was the meaning of his name. He became the leader because he strongly believed that Simigak had seen Jesus. He thought of a Keegak as a person who was looking after all the people like a God. Keegak was the God in the first religious time.

In the giant igloo the people gathered to worship. Keegak was dancing and singing. He led the dances and he sang:

I am, I am, I am,
I am the big God,
God thinks of me.
I am
There in Sugluk,
There in Padlee,
I am, here I am.
I am, eee iii, eeii, eee
I am here; I am.

Once he danced naked. He was a saint now and he no longer had any sins. He was dancing wildly. His male organs were swinging all over the place. His belly had red marks from dancing so wildly. He danced and danced. But the igloo had no roof and finally he began to get cold. Then he said, ''I am going to Heaven! I am going up; I am going up.'' He told everyone to get out of the igloo. ''Everybody out; everybody out.'' People were confused about what was going on. They began to get out. Inukjuarjuk was the last person to start to leave but when he was going Keegak stopped him. ''We are both going up,'' he said. He said this because he had borrowed Annie, Inukjuarjuk's daughter.

But Simigak didn't like the idea that only two people should go to Heaven and he said, ''You are not the only ones who are going up; you are not the only ones going up. We are all going up.''

Of course nobody got up. Finally Keegak had to go home because he got too cold. His penis had goose pimples.

After this, whenever Evitah, Keegak's daughter, went to visit people they used to ask her, ''Has your father gone up yet?'' She used to answer, ''No. Because the Eskimo people have too many sins.''

Keegak was singing in the igloo all the time. He sang that the same things were happening in other places. He saw that Sugluk people in Arctic Quebec and Padluk people around Pangnirtung had the same things going on. People thought Keegak had become a shaman because he could see what was happening in other places.

While the people were like this, they appointed a special person to cut the women's hair and shave the beards. Too much hair would drag people back when they were going up. The women had cold heads! And Martha,

Peter Pitseolak sometimes took photographs to help him make drawings. For this series which he later used as a guide for illustrations, Keatuk campers acted out a well known adventure of Taktillitak. According to Eleeshushee, Peter Pitseolak's half sister, Taktillitak is not a legendary figure but a real man; his very old daughters were alive when Eleeshushee was young. In this story Taktillitak while hunting for sea birds was carried away on an ice floe to a very small island where he ran out of food.

Taktillitak built his own grave and lay down to die.

After dreaming of seals, he got up again and killed a seal with a club.

He made a sealskin float and paddled to shore.

He walked over the land and reached Taseeujakjuak camp.

His friends were so happy to see him they cried.

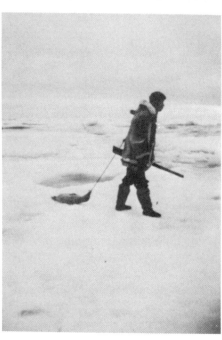

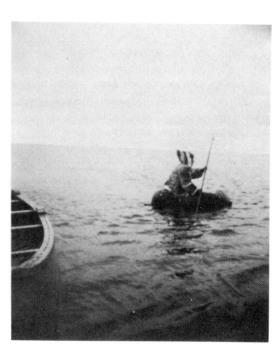

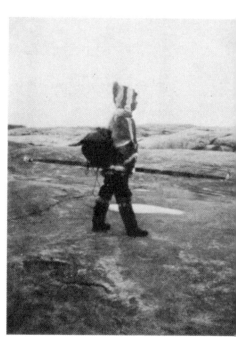

Keegak's wife, would chew on the blubber and put blubber oil all over the clothing, especially on the new clothing. She'd say, "You're too neat; you're too neat." Pretty soon Martha and Keegak were the only people who had good clothing.

This happened after Okhamuk – Reverend Peck – had preached to the people that they should not be so possessive of their things. The people had seen Okhamuk and a few – only a few for at this time they were just starting to learn syllabics* – had learned to read the Bible. There's a story about a man who was prideful of his possessions. All his clothing was in bright colours. They did not wish to be like him. A person like that could never be saved. So the people threw away all their good clothing and anything they had – rifles and beads. They kept their bad clothing and tried to have good hearts.

People even threw away their food. Anything Keegak asked for he would get. My father, Inukjuarjuk, had brought back from Quebec a plate – it had birds on it. Keegak asked for this plate and Kooyoo, my mother, was too quick to give it to him. She was afraid. Inukjuarjuk was not very pleased about this. "Why did you give that to him?" he asked.

People said Keegak was just like a white man – bossing everybody. All the other camps would bring him meat and he even had women who were not married to him making him clothes. He was a big boss now and he had a white man's jacket made out of sealskin.

Martha and Keegak had never been powerful but, all of a sudden, power was waiting for them. They grabbed it.

In the first religious time when Keegak became a Christian nobody was killed in our land although around Pangnirtung there was a killing at this time. There were no killings here but I think Keegak and Martha may have been trying to kill someone. In that giant igloo where they used to sing Keegak and Martha beat up two people. They were out of their minds, like white or Eskimo people when they are drunk. Keegak was jumping on the front side of a man who was lying on the ground. Martha was doing the same to a woman. The man's son told Keegak to stop jumping on his father so the man didn't die. This man was on the ground because he wasn't supposed to refuse if Keegak told him to do something. People were thinking that when Jesus was crucified he wasn't fighting back. So this man didn't fight back. No doubt he was trying to copy Jesus.

*The phonetic system of writing introduced by the missionaries in the late nineteenth century.

But even then they knew they were making mistakes. Simigak, Keegak's cousin, told him that only my father, Inukjuarjuk, and Simigak himself would be going to heaven because everyone else was making too many mistakes to get up. Keegak realized then he was wrong and said, ''We're going to go along with you.''

So Keegak wasn't a Keegak — the leader — any more. When he realized his name was wrong he wanted to go back to his old Inuit name, Annoyak. Then he took his baptized name, Jayko. He was really a friendly person. Most of the people liked him. He wasn't good looking but he had a good personality. He did some wrong but he was really a good person at the time he died. . . . always trying to help with food. He died in 1923 and he is buried down in Etidliajuk in one of the two big barrels left by a ship.

One year after the first religious time, I would be born.

Iceberg off Seekooseelak.

An igloo with ice window built at Keatuk
in the late '50s by Peter Pitseolak for
his daughter Udluriak.

My early life

My birth
Our visit to Arctic Quebec
Why people left Seekooseelak
My first visit to Lake Harbour
Getting the wooden boats
Our musical instruments
The people who changed names
New people in Seekooseelak
My brother's death
The way we shook hands
The second religious time
Fetching relatives from Toojak
The hunting ship "Active"
The very wrong impostor Gods
Moving camp with the seasons
New houses for the ministers
Why babies are adopted
My cousin Etidluie's death
The coming of The Hudson's Bay Company
The shipwreck in which the white men lost their lives
The first shiptime in Cape Dorset
Eskimo mail
Robert Flaherty in Kamadjuak
Noogooshoweetok, the first to draw
The first Christmas at Cape Dorset
Alariak's visit to Tallilayu
The story of Commock
Why Eskimos were no longer free
My first polar bear
How we hunted seals
Taking back Napatchie's wife
Summer caribou hunting
The great winter camp at Eteenik
The Americans at Schooner Harbour
Our relatives in Greenland
The Laplanders
The first time I worked for the white man
Picking my first wife, Annie
The death of Johnny
Starvation
Going to the High Arctic
Working with the flyers on Nottingham Island
Our mother's death
My return to Cape Dorset

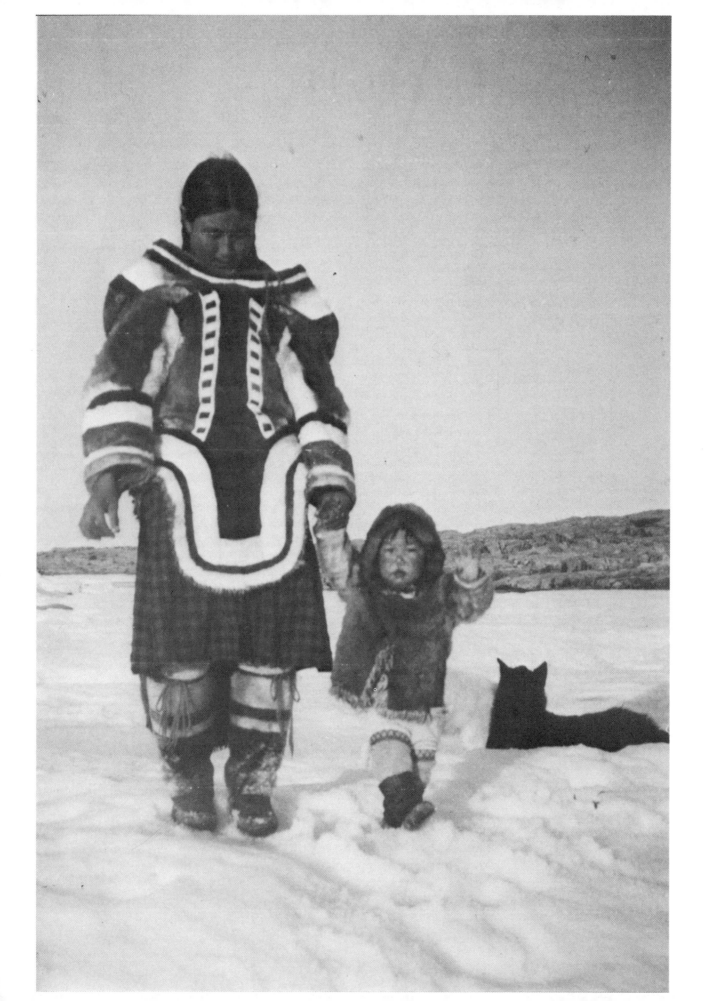

Aggeok with Mark Tapungai. About 1946.

To start with I was born on Nottingham Island in November, 1902. There was no calendar when I was born so I am only guessing and I do not know the day. But I think I am correct the month was November because, even a long time ago, people knew the season of their birth. When November was on, the snow was good enough for making snow houses. It was remembered that, when the snow houses were freshly made, I was born on Nottingham Island. I know almost certainly the year was 1902. My parents always knew how many winters I had and, when I was old enough to calculate back, that seemed to be correct.

It will be hard to believe what I am about to write: I can remember before I was born. It seems like a dream. I remember I had to go through a very narrow channel. The passage was so narrow I thought it would be impossible. I didn't realize the passage was my mother — I thought it was a crevice in the ice. That ice crevice must have been my mother's bones. I remember it took a long time to go through. Once I turned back — it was too hard. But finally I was outside; I was born.

I think I opened my eyes inside my mother but after I was born I opened my eyes again and all I could see were two little cliffs on either side of me. I often remember this: I saw something blue and those cliffs which were exactly the same.

What I remember seems like a dream. It may seem that I'm telling a lie but it's true.

It was said that after I was born I never cried. When babies are born they cry. When I was born I was looking to see what was around but all I could see were those two cliffs, which were probably my mother's thighs. It was said that, when I was in the rabbit pouch and my head was still wet and steaming, I smiled at my sister Nee. I do not remember that smile but I did not cry.

When Parr heard that I smiled right away, he came over next day to see me. He tried to make me smile — but I didn't feel like smiling.

Parr had heard I was born with a smile. I remember him trying to make me smile. It's like a dream. I remember the front of his parka was sloppy and wet. Parr*, who in later years became my brother-in-law, told me to smile that day I remember so well. His mouth was dripping which made his parka wet. I did not want to smile but he had heard I was smiling right after birth.

*Like many mentioned in these pages, Parr in later life received unexpected fame. At the time of his death in 1969, he was one of Cape Dorset's best known graphic artists.

49

Kooyoo and baby.

I do not remember all about my life – there are times that I don't remember. But I remember from a long way back, from before I was able to talk. There must be others who remember before and after being born but they don't tell their story.

After I was born my family moved on to Arctic Quebec. We were in an American wooden boat but it had no motor, only oars and a sail. My father was going to see his brother, Kavavow. Years before Kavavow had been on Baffin Island but he had returned to Arctic Quebec where he had come from. My father wanted to see him once more. But when we arrived all we found were the belongings of our people. They had fled because an Eskimo man was killing many people. We heard this later but when we landed my father was very puzzled. He knew those who had fled were not starving because there were caches of food in the rocks.

Since he could not write he told Mukituk, who had taken lessons from Okhamuk, the minister, to write a letter for him.

She wrote: "We do not know what has happened. You have so much food and so many belongings. We do not know if you are still living. We are taking some of your belongings."

The things we took were some very good mittens – they were knitted – that belonged to Kavavow's son, Etidluie, some tools, and an old-fashioned chest that belonged to Ottochie, Kavavow's adopted son. Mapaluk was there, too, but he probably didn't have anything that was worth taking! Those brothers were always very well-to-do. They were always rich whatever they were doing. Etidluie was the richest so he was chief.

After Mukituk wrote the letter we were on our way back to Baffin Island before the ice came. When we were back on Baffin Island again, the ship "Active" came and from those on the boat we learned of the Eskimo man who was killing Eskimo people. He had gone crazy in his mind. He really hated people so much he wanted to kill. He was a mad person.

We learned then that Kavavow was dead but he did not die in the killings. He died before, from a heart attack in the porch of the snow house. He died because he was old.

When we knew the family was alive, my father tried to return the things we had taken from Etidluie and Ottochie. But they said, "Keep them; they are yours."

I didn't cry when I was born but afterwards I cried so much my mother almost gave me up. There was the couple, Martha and Keegak, both dead now, and when I was taken to their home I would stop crying. I remember going to their place as a baby.

It was because of Martha and Keegak that people found out I remembered being born.

When I was beginning to understand things, I heard of the attempted killings in the first religious time. "Not Martha and Keegak, they were such good people," I said to my mother. My mother said, "Martha and Keegak, you don't know them — you saw them only when you were just a little baby." My mother was so amazed, she called out to her 'aveeliak' — her husband-sharing woman, "Come here a minute, this boy seems to remember when he was a baby."

I told about my visits to Martha's house and that's how people found out I remembered so much that happened when I was a baby. When I was questioned, I answered correctly and they said it was true. I told them all the events I remembered and it was all true.

I do not remember every day. I am saying only the things I remember.

I remember wanting to eat meat. I kept crying and crying but, of course, I was only a baby. Probably I wanted to eat meat because I was named after someone who starved to death. That time, when I wanted to eat meat when I was only a baby, seems like a dream.

I remember when Melia caught a wolf in his trap. His mother, Sheojuke, cooked its meat on her kudluk. My brother Eetoolook, got some from Sheojuke and brought it home. It was a part of the wolf that looked like a tongue, and as soon as I saw it I started to howl. (When my mother wanted to curl me behind her back and I didn't like the idea, she would pretend to howl and say, "The wolf will get you.") That part of the wolf which Eetoolook brought home I thought was used for howling. As it turned out, that wasn't so but when I saw it I started to howl. People were amazed that I did such a thing. I understood everything, they said. I knew that wolves howled.

My mother told my older brother, Eetoolook, "Let your brother have some meat." My older brother said, "Later, later." That also seems like a dream.

There was not much meat to go around so when "later" came, he gave me the bone to chew on.

Aggeok feeding dogs.

Untangling dog traces.

They often fooled me when I was little. When my family was having 'meeseerak' – the aged blubber sauce – I wanted to eat some, too. But when I tried to dip my meat in the sauce my mother said, "No, no, you'll only get yourself messy." She said to my brother, Eetoolook, "Let's fool him and only give him water." But I knew it was only water so I drank it from the cup.

Sometime after I was born our family was left behind in Seekooseelak as our land was called.

When I was born the chief camps were Ikirassak – meaning 'strait'; Etidliajuk – 'short cut'; Egalalik – 'where there is a window'; and Satoretok – 'place of thin rocks.' These were the most popular camps when I was a boy. Ikirassak was the most often and the longest used. Once in the days before the white people lived in the North a white man came to Ikirassak. He was scared. He said, "I've never seen so many people."

But around 1904 or 1905 people started moving out toward Lake Harbour because they wanted to be near the white man's trading post. When the store opened some moved to that area and some moved to Tunikta, the area around Markham Bay. But they returned well before the Hudson's Bay Post went up in Cape Dorset. They returned because they were hungrier in that area.*

Issacie, who was related to me, and his wife were the only family who stayed with us. At that time many dogs died. The dogs that died were enough for four dog teams. My father and older brother, Joanasee, my brother Petalosie, my cousin Issacie, all of them lost their dogs. The only dog left was my father's lead dog.

The dogs went 'seenowgatoot.' We have different names for this illness in all the regions. They went crazy. The foxes went crazy; a caribou was seen to be crazy – fighting with a rock – and people said there were wolves that had gone crazy.

After all the dogs died we were not able to make up a team. We had to wait for summer and then we went to Lake Harbour by boat.

*This was a depot run by the Robert Kinness Company of Dundee, owners of the whaling ship, "Active," and operators of a mica and graphite mine in the area of the present settlement of Lake Harbour. These early activities influenced the later establishment there of the Anglican Mission Station and the first Baffin Island Hudson's Bay Trading Post.

A seal feast at Keatuk.

All my life I have remembered my first trip to Lake Harbour.

I am only guessing but maybe it was 1904 or 1905. I was hardly walking, just learning to walk and always falling down. We went through Aulassivik – the caribou training grounds – where we saw people. The young people held my hands. Kovianatukulook and Leevie were calling me their first cousin. One person had a short haircut and I didn't like it. It turned out that Leevie had the haircut.

I remember entering Lake Harbour on a very calm day. I remember Lake Harbour had so many tents. When we landed there Keeleetee, my mother's stepbrother, shook my father's hand and started to cry. I started to cry, too. He was overjoyed to see my father. He was the first grown-up I saw cry. I thought grown-up people never cried.

While we were in Lake Harbour, my father asked my mother to go with him to the store, so we went. When we entered the store through a hole in the wall I saw a person just like my mother and wondered who it was. The likeness of my mother was carrying a baby in her hood. Whenever I moved, the other baby in the hood would move too, just copying me. We were looking in a mirror. Because it was the first time I had ever seen a mirror, I was wondering who looked like my mother. Then I was wondering why the little boy was copying me. It was my mother and me all the time. We were that primitive.

I saw my mother in the mirror and I really liked her. I never saw anyone with longer hair. It was double braided. My father had really admired her so he bought her with a rifle and a lead dog. Just because he liked those braids. Her father said, "No!" but he got her anyway. She was beautiful.

By Eskimo custom my father, Inukjuarjuk, had many wives. My father never went around with women behind people's backs but the people did not know God then and had many wives. Even though white people did know God, they also used to have many wives – I've read it in the Bible. We all know that Abraham had many children. When I was very little my father had two wives. My mother, Kooyoo, had seemed to be his only wife; then my stepmother, Kowmadjuk, whom I knew well, became his second wife. (I've never found out if he was married to Eleeshushee's mother, Khreemipikulu; and Petalosie's mother, Nirukatsiak, had been his very first wife. My father treated them like sisters. He helped them with food and clothing but I know not if they were his own.)

My father had many children. With his Nirukatsiak he had four children. With Khreemipikulu he had one, Eleeshushee; and with my mother he had

Ima and child at Keatuk.

eight children. Only good hunters had many wives. Only rich people could afford them.

Our camp-mates were buying so many things. My brother Joanasee, my brother Paulasie, my brother Petalosie bought rifles. The geologists who were there gave them the shells. They gave them many and people were always careful to save what they had and not to use too many.

Now I will relate about the return journey. Joe, who was married to Kooyoo's sister Lao, and his family came with us. My cousin Issacie was told by our uncle Pudlat to stay behind in the Akudnik — 'the middle land. From Akudnik Keeriapik came with us. Joe and his family were travelling in our boat and Keeriapik had a small boat.

Joe had two names. The white people didn't like to call him his Eskimo name, Tooeemee, so they called him Joe. Tooeemee was the first person I knew in my lifetime to speak English. Way before I was born he had worked for people who were making a map.

All the boats had dogs with them. We had to breed our dogs all over again. We bought two bitches and a male. The male dog was a half breed. Years before the white men had brought their dogs and they'd bred with the huskies. That dog never howled or barked but he was all right. He was a good dog. He dominated the huskies.

It was a very messy business having the dogs in the boat. When they wanted to go to the bathroom we'd hold them over the side and pull their tails.

On our way between Lake Harbour and Cape Dorset, we met a person. I thought he was a ghost but he was a man. His name was Manumee. I thought he was a ghost because his face was all hairy. He had a big beard. I have never seen anyone who had such a hairy face! That's why I thought he was a ghost.

With him was a lovely little girl; her name was Ningeookaluk.

Later she married my brother Pootoogook.

They had been left there for the day because their boat was too small and their people were on their way to summer caribou hunting. They were to be picked up on the second trip.

Later on we happened to meet the person who had left Manumee and that girl. Sa Amorok was his name. He turned out to be Manumee's son-in-law.

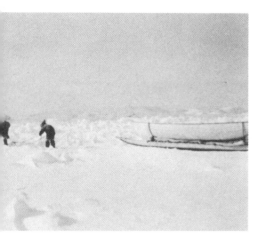

Preparing to transport a boat by sled to the floe edge for seal hunting.

He had young seals in his boat and in his kayak. I remember him pulling the seals from his kayak. I remember all this though I was still being carried on the back. I also remember the seals were shot by a rifle; that's why there were so many.

When we got back we camped for the winter at Ikirassak. I might be wrong but I think it was at that time Keeriapik, Petalosie and Noogooshoweetok killed enough walrus for the whole winter. This was at Ooleejuak. You can still see the bones of these walrus at Ooleejuak; they are at the lower side. These are the walrus the people killed. You can still see them even though it happened a long time ago.

When we went to Sahrok, a big island where people often stopped in the spring, I remember my father making a boat all through the spring. He was making an ordinary sealskin boat even though he had an American wooden boat. He said the American boat was too small. He made the sealskin boat just to have an extra boat when we moved. This sealskin boat was not very big but it would hold as many belongings as the American boat.

We started getting the wooden boats from the Americans. If an Inuk killed a whale for the whalers, they'd give him a wooden boat.

The baleen whale used to be very valuable – its oil was, but the baleen was more so. The baleen was huge. If a man carried it on his shoulder it would touch the ground on either side. It was very flexible. The Eskimos used it a lot for bows and arrows and harpoons. I don't know what the white men wanted it for but the kadluna wanted it just as much as the Inuit. It was very useful.*

The only time I saw the great whale was when Ashevak and I were lost out at sea in 1965 and were surrounded by ice blocks. Once in a while I see big whales but I'd never see one that big. My father caught two great whales. One had been harpooned but was still living. My father took a paddle, tied a knife to it and killed it with the paddle.

The kayak used to go right up on the whale . . . just for a minute. No, it wasn't dangerous – for a good hunter.

*Instead of teeth, baleen whales, like the right or bowhead whale, have hairy slats of baleen which hang in the manner of venetian blinds from the whale's upper jaw. This traps and strains the tiny sea life which is the whale's food. The baleen was used for women's corset stays and horse whips. Today the bowhead whale is almost extinct. Some authorities say there are less than twenty bowheads in all of Hudson Bay.

Readying the dogs.

When I was growing up every summer we went caribou hunting inland.
We walked from the ocean carrying our kayaks and then we put them on
the long lake. We would stay inland until we had enough.

We went across Taseeujakjuak — the giant lake. My father, my brother
Petalosie, my uncle Joe, Keeriapik, all were travelling in their kayaks
through Taseeujakjuak. There we met two more ''ghosts.''

My father had me with him; Joe had his wife and son, Mialia, with him;
Keeriapik had his son Oelagee with him; my brother Petalosie had with
him his blind mother, Nirukatsiak. My ''ghost'' guided the blind woman
Nirukatsiak ashore. I thought she was led by a ghost but the ghost was a
person. I thought these people were ghosts because I never saw people
except those from our camp.

Also, because they had beards, that's why I thought they were ghosts.

The more ghostly one had a big mouth when he laughed. It turned out
his name was Elee; he was the father of Kovianatuliak. I have never seen a
real ghost but I thought I had seen one that time. It was because I was not
too bright.

It was then that those men, Elee and companions, told our people that my
cousin Issacie had died. That morning, Alashua and her aveeliak — her
husband-sharing woman — came to our camp for a little while. Both had
their sons, Parr and Simee. My mother woke me up. She told me to get
dressed. She said, ''Wake up; we're getting ready to move.'' She was
talking about a cousin. I thought she was talking about Issacie but she was
talking about Parr. I asked her if we were going to visit Issacie. Then she
told me Issacie had died.

I asked my mother, ''Is Parr the man who tried to make me smile?'' My
mother was really surprised that I remembered this because the day Parr
tried to make me smile I was only one day old.

In Sasukrauk we were together with Elee, his son Kovianatuliak, and Jayko.
They had moved there and we went to them. When we got to them, for the
first time I saw the music box. Guseevie was playing music and I remember
I really liked it. I thought that she was ever so smart to play and I really
liked the music box. It turned out that it was just a very old music box. It
was so old that it was tied together with caribou sinew. It had cracks and
they had had to put dirt, like putty, in the cracks. That's all they had for
putty a long time ago. In Kakook that year many walrus were killed — that
time when we had the lovely music box.

Aggeok playing the accordion.

Guseevie's music box was the first kadluna's musical instrument I ever saw or heard. I thought it was such a good one, but it wasn't really good. It was tied together and had dirt in the cracks because it was falling apart.

Guseevie used to play the music box. She kept playing the same tune over and over. It was always the same and never changed. But I admired her playing even though she had only one tune.

Keeriapik also had a music instrument. He had made that instrument himself. This was another instrument that I admired. When Keeriapik used to play, his son Olaegee danced. The 'taoteeghroot' was nothing much, but I really admired it.

They made it way before the white people were living in the North. The main piece was made of driftwood. In the middle they would make a hole and towards the narrow and wide ends they would put pieces of wood. Then from end to end they would put sinew thread — three of them — close together. They made sure that it was very tight. They would get another driftwood and they would make it arched. They would get the baleen of the whale and attach it to the driftwood ends. They would put the instrument down to their foot and up to the chest and play it with the bow. It sounded like the violin. We had it way before the whalers, way before the white men came. It was true Eskimo.

I am going to tell another story — about two boats arriving at our camp, a small boat and a big Eskimo sealskin boat. I will call the people who came by their old names.

When I was growing up I knew people who changed names as often as they felt like it — without being baptized. They were always looking for better names. When we started to be able to read the Bible, people would pick names from the Bible and say, ''Maybe, if I have this name, God will save me.'' If people could not read the Bible, someone who could would pick a name for them. It didn't always have to be Mosessee. They'd pick names that were related to the Bible. There was Kumwartok — 'going up,' Kaka — 'hills,' Gotilliaktuk — 'going to God.' There was one family with a Namoonie — 'where can I hide myself?' He was married to Kumwartok — 'up to God.' Their daughter was Samayo — 'peacemaker.' One family had Nuna — 'land,' Panni — 'up,' and Tapanni. That could mean, 'We will meet up there in a beautiful land.' This all started around Frobisher Bay . . . the Frobisher Bay people were first.

Pulling a square flipper from the seal hole. This picture was taken near Keatuk about 1944 by Aggeok (she says Peter Pitseolak set the camera) just after the seal was caught. Left to right: Kooyoo, Ashevak, Peter Pitseolak, Pingwartok.

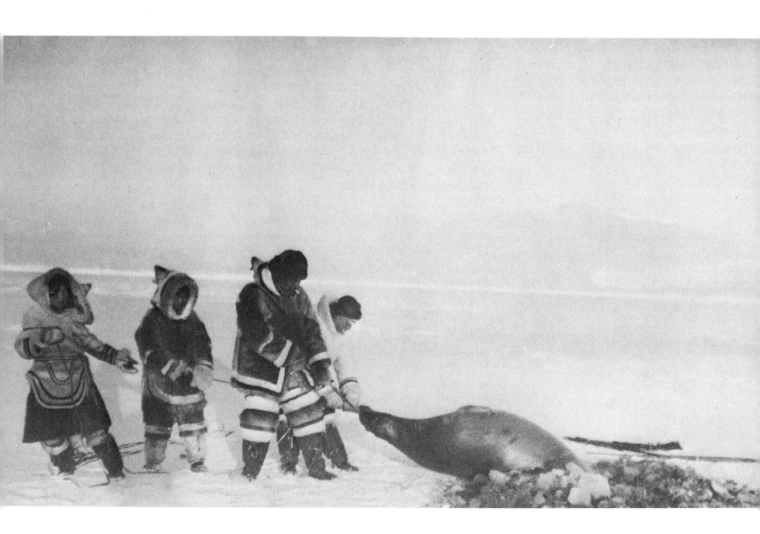

These are the people who came and the names they were called; Seoneonie had the small boat. With him was his brother Sila and my cousin Mateeosie. Seoneonie was the captain. Seoneonie's wife was Sanik, their daughters Eeleeakeemeek and Nakutaleeak, and adopted son, Pee. Sila's wife was Nee, the aveeliak was Kudluajuke. Sila's daughter was Akeekulook, Mateeosie's wife was Eekualajak. Sila's brother was See, who had no wife.

In the skin boat Meelia was the captain. There were Eegyvudluk, Peetee, Eejunitook, Jousa, their families and Captain Meelia, and his wife, Kivalavik, which in English means a sundial, and their daughter Keegak.

These people were returning to Seekooseelak from their camp Koayana in Tunikta — the place of Tooniks — because they were hungry. They would rather live in Seekooseelak. They had wanted to go to the Lake Harbour area because they wanted to live near white people.

After we met Elee and companions in the summer at Taseeujakjuak we moved to Etidliajuk to camp for winter. But we moved on again to Odlee, a good place to hunt.

There three dog teams came to our camp. My uncle Pudlat, his son-in-law Ahlerak, and Noamee were on one team. Pudlat's wife was Sugalak, their son, Keeleepalik. Ahlerak's wife was Eeteriak, their son was Noamee.

On the second team were Eesoohageetook, his wife, Ooleesia, Ahlakak and his wife, Geegoolusalik. Ahlakak's son was Lutakulook, his adopted daughter was Pee. Eesoohageetook's son was Issacie.

On the third team were Eenoosee and Simonie. Eenoosee's wife was Salatee, Simonie's wife, Gooana.

These were the three dog teams that came to our camp Odlee.

My late brother-in-law Ahlerak made everyone pray. He was powerful in that. He seemed to know everything there was to know. He couldn't know all about the Bible but he was greatly able. He was the very first Inuk I knew who gathered people together for prayers.

I am telling a story about how Seekooseelak grew. I am not telling about everything, just what I remember from early times of the doings of the Eskimo people. There are so many things I know.

That spring my brother Joanasee died by a kayak accident. That occasion I do not like recalling. All my family were very saddened. My brother was such a great hunter; it seemed there was no animal he could not get. Before he died I had never known what hunger was. That winter, when the days were longer, that was the first time I met hunger.

Joanasee, our oldest brother, was caught by some kind of monster. I've heard that it was a shaman's demon that got Joanasee. That's what I've heard. The shaman was probably jealous because Joanasee was such a good hunter. I don't know who that demon belonged to because the people would never let Joanasee's relatives know. They were afraid of what the relatives might do.

Joanasee feared something would happen to him. He feared someone would get him. Once when he went hunting a piece of ice appeared suddenly up from the water. He thought it was a shaman's spirit though it just turned out to be ice. After this time, whenever he went hunting, a big piece of ice would suddenly appear. He was afraid so he always would have somebody watching him while he was hunting.

This time Pootoogook was walking on the ice while Joanasee was in the kayak.

Pootoogook never told the story of how Joanasee was killed by a monster although he knew what had happened. He had a hard time when Joanasee was killed. In all his life he was never more scared than that time. And it hurt his feelings to remember the whole story over again. He wouldn't tell the story because he loved his brother.

Joanasee shot a square flipper seal. He harpooned it after he shot it and the sealskin float didn't have enough air; it went down. Joanasee was waiting for the float to reappear when the monster attacked the kayak. The kayak stood right up on its end. As soon as he saw the monster, Joanasee died. Once or twice he tried to paddle but he couldn't move. He died. That's what Pootoogook told someone – not me – maybe his mother.

The sealskin float appeared later, after the square flipper died. But they said it wasn't the square flipper for sure.

After Pootoogook had seen what happened he ran home to get help. At that time people used to get together to eat and they were just starting their food when they heard shouting for help and they went to get their kayaks. They saw Pootoogook waving and shouting and crying and they realized he had lost his brother.

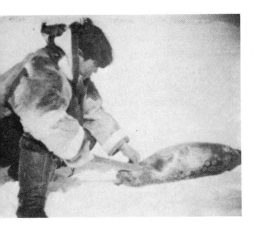

Ashevak Ezekiel, aged about 19, cutting up a seal to make an avatuk — the sealskin float hunters tied to their harpoons.

The only thing Pootoogook ever said about the death of his brother was that water is soft; you sink in it; you can't walk on it. He didn't have a canoe so he tried to walk on the water. He didn't know what he was doing.

Once Ningeookaluk, Pootoogook's wife, wanted to understand what had really happened but Pootoogook said, "I don't want to be asked any questions. I tried my best at the time but I couldn't do anything."

My brother Joanasee was a real man. We were all hungry after he died because he seemed to be the one who caught most of the food.

The year after Joanasee died, two dog teams came to our camp in Ikirassak: Simonie's and Atanik's. Simonie's wife was Annie.

My sister Eteriak had sent a message by Annie. She and her husband, Ahlerak, had been to Nottingham Island on the "Active," the whaling ship, and met our people, my cousin Etidluie and his brothers. In the summertime Eteriak met Annie in Tunikta and told her to tell Inukjuarjuk that our people were at Toojak — Nottingham Island.

My sister Eteriak said my family should go and get Etidluie and his people from Toojak where they were camping. Etidluie and his brothers had sent a message that they wished to move.

When the messengers arrived, that was the first time I saw a handgrab move. People I'd seen before always took the hand and let go without a shake. There was another kind of handshake which I never saw but heard of: people would grab each other's wrists — no shake and let go. This was only done with close relations. I have forgotten how they used to do certain things now but I think that was the way. It was only close relatives who would ask to take the wrist. The first time I saw a handgrab move was when Simonie and Atanik arrived. When they handgrabbed each, other and started to shake I thought something was wrong. It was a quick jerk. I do not know the old, old way but that's how I came to know what I have told.

It was decided that my father would go next summer to get our relatives by boat.

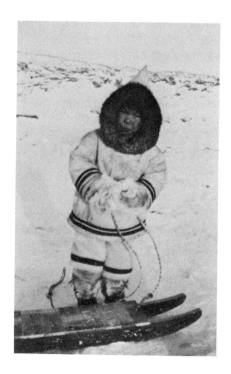

Mark Tapungai with toy sled.

My story is not in sequence though it seems that way. Even our Bible is not really in sequence. In the Bible the first people just have to lie side by side and they have a baby. And the new born is able to do powerful things in no time. My story is like that; it is not one thing after another.

Now I am going to tell another story. It's not in sequence with Etidliajuk camp life.

The people of Etidliajuk had confessed to get rid of their sins. My mother had asked to go to where the "saints" were, so we all went. They had just confessed so they had to be very good. When they were asked to dance they would dance right away!

This was the second religious time. When a person was told to do something, he'd do it right away because he'd want to be saved. People danced so much because they had to say yes when they were asked. If they refused, the leaders would think they were not religious like the others. If they danced, they were saved. If a person didn't refuse, he'd be respected like the others. He was saved.*

We were beginning to get hungry so my mother envied the saints — they could get any animals they wanted to get, at least it was heard as being that way.

A man named Josa was told by his wife, in the hope that he might confess, that people in Etidliajuk had plenty of food. "Whenever they go hunting, they have animals; whenever they go after young seals, they get young seals. Because they no longer have sins they now have plenty." That is what his wife, Kowmajuk, told him. Josa replied, "People with sins have no trouble getting seals either." That is how he replied. Josa's answer, this reply to his wife, was laughed at for many years.

My mother asked to go to the saints for a short while so I was able to see dances — they had many different dance styles.

They no longer wanted to be "big people." Now they were saints. But they were going the wrong way.

Elee's wives, Guseevie and Alashua, were leading the dances. At that time Alashua was called Evie. She was Alashua first, then she changed to Evie,

*A third religious time occurred among people living on the Belcher Islands in 1941. Accounts of it have been written by Ray Price in *The Howling Arctic*, Peter Martin Associates Ltd. (1970), and by Fred Bruemmer in an article entitled "The Belcher Islands" in the summer 1971 issue of *The Beaver*.

66

*and then she changed back to Alashua again. When she had finished
reading the Bible she realized Evie turned her husband Adam into a sinner,
so she went back to Alashua. She didn't want to have so many sins.*

*I remember a lot about those dances. Lukta was trying to dance but he
stopped immediately. He said, "Oh, I have made a mistake." Maybe he
couldn't dance. But he was commanded to dance by the leaders. If he didn't
dance he wouldn't be saved.*

So he danced; he was saved.

Those two women were very intelligent!

*The second religious time was going on during my childhood. At that
religious time more than one settlement was overdoing religion.*

I had a brother who was mentally retarded. The poor man could not walk;
he could not talk. He was not born to my mother. He was born to my mother's
aveeliak, Kowmadjuk. The poor man was my father's son; he was my
older brother. It could not be helped; sometimes people are born that way.

It could not be helped but people wanted to throw him away. They thought
he had the devil in him. He wasn't like any other human being.

Khreemipikulu was told he ought to be thrown away but she didn't listen to
the people for a long time. But those people, Guseevie and her aveeliak,
Alashua, who had turned into saints, who had danced and danced, kept
telling her again and again to throw him away. She finally agreed to throw
out her grandchild.

The poor man was alive when they took him outside. When the two who
were to throw him away were in the house, he became very quiet and still.
He was known to make strange noises all the time, as crazy people do.
He acted like a different person. He was staring at those two people who
were to throw him away as if he were studying their faces. His grand-
mother put him in the wrappers. He could not speak a word at all as he was
crazy. Suddenly, so clearly, he said, "Amen, Amen, Amen." He said this
very clearly. When he was about to be left in the snow blocks he said again,
"Amen, Amen, Amen." He had never said a word, not once. He was unable
to speak.

He was helped to say these words by our Helper, we know for sure.

 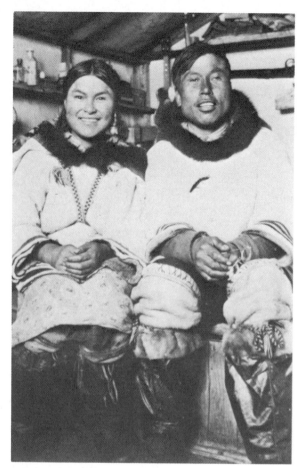

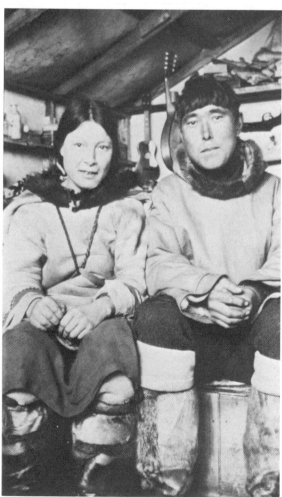 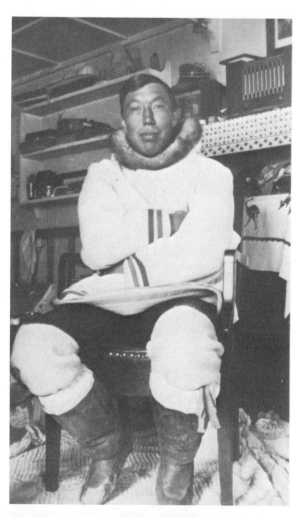

These are things that happened when I was first able to remember.

These people who danced, who confessed their sins, did wrong. When they thought another person was not a saint and they felt afraid, they threw away their fellow human.

When our people were to come back from Toojak — Nottingham Island — we crossed by the Akudluk Island to get them.

Our people had crossed from Noogite in Arctic Quebec to Toojak. These were my father's relatives, his nieces and nephews. They were the sons of my father's brother, his dead brother Kavavow. They were Kavavow's surviving heirs. When my father learned that they had reached Toojak, he wanted to go and get them.

After my grandfather, Etidluie, had died — his bones are around Shabuk — his three sons went to the Akudluk Island — Salisbury Island — for a year. Then Kavavow went on to Northern Quebec — Igloaalook, the large snow house, and Kiakshuk and Inukjuarjuk returned to Baffin Island — Iglooajuk, the small, tiny snow house. Later my father, Inukjuarjuk, and his brother Kiakshuk went to the other side to see their brother. My father went with a long wooden boat and Kiakshuk went by the sealskin boat my grandfather Etidluie had made.

Inukjuarjuk stayed there for perhaps two years — Pootoogook was born there. Then he returned to Seekooseelak.

Kiakshuk remained behind in Arctic Quebec. When he died there he gave the sealskin boat my grandfather made to his nephew Etidluie, my grandfather's namesake.

I will now mention those who went through the islands to Tqojak to get to our people: My father, Inukjuarjuk; my mother, Kooyoo; my late brother Paulasie, his wife, Majuriak; my late brother Pootoogook — he did not have a wife even though he was a young man (in those days they had only one youth); my late brother Eetoolook — he was just a little boy; my sister Eleeshushee, she and I are now the only living children of my father; my stepmother Kowmadjuk — she was my mother's aveeliak and my father's wife (in those days having an aveeliak was not being sneaky; today they are sneaky about it but there are many children being born); her daughter Shovegar, just a little girl, and her son Tukikitoolook, still up on the back; my late brother Petalosie, his wife, Pee, and daughter Pootoogook.

69

These were the people who crossed to Toojak in my father's boat. It was an ordinary wooden boat which came from the Americans. People called it the "longboat."

The year was 1908 when we went to Toojak to get our relatives: I was very little; I was still being milk-fed.

When we had slept out one night and we were almost at Toojak, my father sighted an inukshuk and said, "There has never been an inukshuk in that place. What is that inukshuk doing there?" It turned out that Eenutsiak* had gone for a walk; he was on top of a hill watching us. When he saw us he started to run. Our people acted as if there was a big ship. They were so happy to be with other people.

That year – 1908 – was the year we were brought back to our land by the ship "Active."

The other boats were using their tents as sails. When we landed there were people to greet us.

My father started to cry when he saw his nephew. He told his nephew his favorite son, Joanasee, had died, and he cried. When my father cried I was ashamed of him. It turned out that he and his nephew were very close and that's why he cried; he used his dead son as a reason for crying.

I am now going to tell you how many people and how many tents there were in that camp.

Etidluie was now the captain of the boat my grandfather made and used before him. In Etidluie's tent where we were to stay were his wife, Peeshoo-tee, his sons Kiakshuk and Matchowjak, his daughters Ekateelik, Napatchie and Axaganyu. Also in their giant skin tent were Etidluie's stepmother, Omadluk; her son Udjualuk, and another woman, Matchowjak, and son Tukiki. In Etidluie's giant tent there were eleven people.

In the tent of Mapaluk, Etidluie's brother, were his wife, Ijowt; his sons Sapa, Pameotook and Inukjuarjuk; his daughter Lataluk. Shoojuk, Mapaluk's niece, was also with them. There were seven in Mapaluk's tent. They also had a bear as a pet; the bear was living with them.

*In later life Eenutsiak became known for unique carvings, described by Peter Pitseolak as "little groups," depicting scenes from old Eskimo life – childbirth, prayer meetings, wrestling matches. He died in the middle '60s in Frobisher Bay, into his eighties and on his way to church.

Pitseolak Ashoona.

In the tent of Ottochie, Kavavow's adopted son, were his wife, Timungiak; his sons Ohituk, Kavavow and Napatchie; his daughters Akiagok, Kudluk and Pitseolak.* Pitseolak was still being carried on her mother's back. She was a big baby who had not yet had a birthday. Their servant who was almost an older person was Omaluapik. In Ottochie's tent there were eight.

Pudlalik's wife was Adla, his sons were Manumueekudluk and Pitseolak. In Pudlalik's tent there were four people.

Kavavow's wife was Kasogiak, his son was Ottochie, his daughter Koopigooluk, his stepdaughter Kiakshuk. (She was the daughter of Kavavow's wife by a white man); Kavavow's mother was Meeleetiajuk, her daughter was Samaleenee. There were seven people in Kavavow's tent.

In Keegutak's tent there were his wife, Atteetuk, and his blind daughter Ohituk, his mother, Manumialuk, her daughter Annagajuarak, and Annagajuarak's daughter Manumialuk who was named after her grandmother. There were six people in Keegutak's tent.

There was also the tent of Annagajuk. She was a widow. She lived in a tent with her two children. Her son was Eenutsiak and her daughter was Aguteewoluk. There were three in Annagajuk's tent.

These were the people who were living in Toojak.

When we arrived there was a prayer session. That was the first time I have ever seen people kneeling. I thought they were so clever. Mapaluk was their singer; Ottochie, Omadluk and Matchowjak were their ministers. I thought they were so clever. But they were just following what they had heard. I admired them so much because I thought they were so powerful when they were praying.

I am going to tell more about this in another place.

Altogether the people living in Toojak whom my family tried to come and get were 46. They were that many and they had an ordinary Eskimo sealskin boat. Then a ship arrived — the ship, "Active" — and the "Active" took us back to our homeland. We went on the "Active" which took us to Tikerak, near Cape Dorset. We were aboard and our boat and also my cousin's boat were riding on the ship. The "Active" was a big ship which

*Pitseolak Ashoona, today one of Cape Dorset's most talented graphic artists. Her story is told in *Pitseolak: Pictures out of my life*, from recorded interviews by Dorothy Eber, Oxford 1971.

71

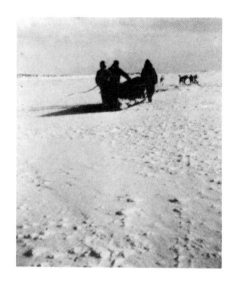

the whale hunters owned. The ship's people were 'Seecottsie' — Eskimo for Scottish.

Altogether with the people from Toojak and all of us, we were 57 persons. There were that many of us taken to Tikerak on the ship "Active," and brought back to Seekooseelak in the year 1908.

Now I will tell about the regular journeys of the "Active."

When the "Active" arrived every year at Lake Harbour, the Eskimos would get on. The "Active" was a hunting ship and her crew would get the Inuit to help them with the hunting work. They would get on the ship in the new spring when the birds were beginning to lay eggs and they would ride on the ship all summer until the fresh autumn. They even went as far as Repulse Bay.

I remember the people from Lake Harbour. I do not recall all the women and all the little boys and girls; there were so many. But the men I remember. Those from Lake Harbour who were working on the "Active" during the summer of 1908 I remember so well. People my age can never remember what I never forget.

That summer those who could not go walking-hunting stayed and fished. Everybody else crossed over the long lake for walking-hunting.

When we got to the 'sapotit' — the rock weirs where the people trap fish — Inukjuarjuk, Petalosie, Pootoogook, Etidluie and Poolalik did not go on. My father was then too old, and Pootoogook was unable to walk. He had a wound on his leg — it had been shot by a rifle. Petalosie had bad legs and Poolalik had a bad ankle and did not wish to go on account of his ankle. My cousin Etidluie just did not wish to cross the lake; he went walking-hunting for caribou in the area, carrying the meat on his back. At that time there were plenty of caribou.

Then we moved on again to Etidliajuk and to those who had crossed the long lake for walking-hunting. Here was the first time I ever saw anyone praying to somebody who was not God or Jesus. They were praying to Ijowt Inuknak, Mapaluk's wife. I remember that Timungiak was praying to her sister-in-law, Ijowt Inuknak. In her prayer she said, "Lovely Inuknak, I am praying to you because you are the God." This is what Ottochie's wife

was praying. Lutaluk, the daughter of Ijowt and Mapaluk, was also some-one who thought she was God. Lutaluk, the lovely daughter of Mapaluk and Ijowt, was picked as a God for the reason that when she was born from her mother, there was lightning. These were the very wrong impostor Gods.

Some people said Omadluk was worse than the others as far as Lutaluk was concerned. Omadluk and Timungiak were overdoing. They were wrong in their beliefs. God and Jesus are our only Gods; it may seem that they are not there because we cannot see them but we are not to pray to what is visible. There is a belief that if a man helps another in his errors, he is also doing wrong. Those two, Omadluk and Timungiak, they were overdoing their beliefs.

In the second religious time only the people who had come from Notting-ham Island had Gods.

When we were about to settle in Etidliajuk for the winter we went to a wrecked ship that was still upright.

When that ship was wrecked my uncle Pudlat had been on board. Its propellors were broken and the captain didn't want it any more. He ran it up on the shore and left it for the people.

Our people went to the wreck and Mapaluk and his brother took wood to make sleds. Ottochie was trying to knock over a large piece of wood from the top of the wreck. Suddenly, this large piece of wood fell and Ottochie went with it. He was unconscious. He had to be carried home. When he came around again, he was a little bit crazy. Because he was a little bit crazy, he was making strange noises. We children were trying to imitate him. This is the way he sang, "Leakeye, leakeye, leakeye, leakeye, leakeye, beside Moses' tracks, leakeye, leakeye, leakeye, leakeye, leakeye." That was the way he sang after he was unconscious; he was still not himself. We children imitated him because we were nuisances and not very intelli-gent at the time. His collar bone came off. All during 'okiasok' – towards the time when everything is frozen – he had to wear an elbow comfort because of his collar bone injury. When the men went walrus hunting, because of the collar bone, he did not go with them.

When it was almost winter, Samaleenie and Seereesiak became wives, although their new husbands each had one wife already. They became aveeliak. Etidluie took Seereesiak for a wife and Sila took Samaleenie.

73

When winter came in 1909 Ottochie and companions left to go to Seengaiyak, the camp on the point above where Frobisher Bay is now. They went to be with their relatives.

When it was almost 'opingngok' — when we move to where we will stay for summer — Oleepeeka, Sila, Noogooshoweetok, Meelia, Eegyvudluk, Josepee, Sorooseemeetuk, Ohituk, Josha, Etidluie, Kavavow, Kiakshuk, See — these are the male names — spent the season on the Toonikjuak Islands, southwest of Etidliajuk. My people spent the opingngok at Toolukat. Inukjuarjuk, Petalosie, Paulasie, Pootoogook, Mapaluk, Keeguta, Eenutsiak, these were the men at Toolukat.

When the men went out hunting, the big ship "Active" passed by. Manumealuk saw the ship first. It was in the morning. We followed the big ship in our ordinary sealskin boat. I don't think we ever caught up with the "Active."

But the people from Toonikjuak went in their kayaks to meet the "Active." They got tobacco when they traded their sealskin floats.

I am telling a story but it is not one thing after another.

In 1910 we went across Sabarosek, the smaller side of the Shabuk bay, and with Mapaluk and companions we spent the winter in Etidliajuk.

At that time Mapaluk, Noogooshoweetok and Polalik visited our left-side neighbours, the Lake Harbour people. When they came back we heard that the two ministers, Elatak and Inuktahow*, had new houses in Lake Harbour. These were the people who showed the way.

My cousin Etidluie was getting weaker and weaker. His throat was thick with fluid. It turned out that he was to die from this. When Etidluie was not expected to live, my father and others were asked to go to Etidluie's camp. Etidluie had asked for us; we went to them. My father went to him, his nephew. Sila and his wife, Samaleenie, my father and I.

The reason I went along was because I always wanted to be with my mother. Since we did not have many dogs my mother was staying behind. But I ran on ahead before the sleigh started to be sure to be with her.

*Rev. Archibald Fleming, later Bishop Fleming, and J. W. Bilby established their Lake Harbour mission station in the summer of 1909.

My father did not want me to go back alone so he picked me up.

By late night we had reached the people at Eemik, my cousin Etidluie's camp. Etidluie, Keegutak, Meelia who was visiting, and three women were at Eemik. While we were there people who had gone on a trip came back; Paulasie, Pootoogook, Mapaluk, Eenutsiak and their helpers had bought a boat. Mapaluk told everyone that the boat smelled of white man. But it turned out that the smell was from tar.

My late brother Paulasie had brought along Sanganee; it was the first time I had ever seen him. Akatoo in the camp had wanted to see him since he was her son. It turned out that he would never return again to the one who had adopted him. Sanganee was then a young man. In 1911, that was the first time I saw Sanganee.

He had been quite a big boy when he had been adopted and Akatoo missed him very much. Paulasie helped her by bringing him from the family that had adopted him.

People adopt babies because they privately think, "When I grow old there will be no one to be with me, to help me around; no one to hunt and bring in the food; no one to do the sewing." But adopted children are not servants; sometimes they are even more loved than a natural child.

There are some people, not normal in their minds, who will start mistreating an orphan they adopt. An example was Pingwartok. He was so mistreated he was beaten. When my brother Eetoolook heard how mistreated Ping- wartok was, he took him away from his family.

In my life I have also known three men who were poor in every way — poorly dressed, mistreated by their own parents, and by their brothers and sisters. When they grew up, they were able to do better than their brothers and were much admired by other people. One such person was Jamasie. He was very badly treated as a little boy. His family moved away from Lake Harbour towards Frobisher Bay and when Jamasie returned — grown up — Sila said, "You're not Jamasie; I don't believe you're Jamasie." He was unable to believe it; he'd been so poor.

So poor boys did grow up to be respected men. I've even heard they would often be the greater hunters. And I think those people, who had hard times when they were young, try to be kind to poor people. They know what it's all about.

When spring came in 1911, we camped at Khreemeetook, near Shabuk — our family and all our relatives. That year, 1911, we went by umiak through the

bay of Sabamarek. We were only my father and my brothers; Matchowjak and her son, Tukiki, were the only ones with us.

Mapaluk, Kiakshuk, and Eenutsiak went walking-hunting on the land near Sabaroot. (By that time Etidluie couldn't do anything; he was full of disease.) On their way there was a bad fire. As Kumeeleetak was tending an open fire, her skirt started to burn. She was almost getting old then. She did not die right away but she really died from that fire. She died from burns. Before she died she suffered badly.

At that same time Keegutak's mother, Manumialuk, her daughter and grand-child were out picking berries. While Manumialuk was having a bowel move-ment, she started to cough very badly. She was spitting blood from her lungs. A big blood clot plugged her breathing passages. She did not even have time to put back her pants. She no longer had any breath. That was really sad: the old lady was fine when they went off berry picking but she was not to come home again. She died.

When everything was frozen, in the 'okiak' — the autumn of the year — in camp at Sabaroot my cousin Etidluie died. Before he died his wife, Peeshootee, had broken her back and they were no longer moving from camp to camp because they were both in pain.

There in Sabaroot Etidluie died. Keegutak and Kiakshuk, these were his sons; they were his men companions.

When dog teams were usable again, Mapaluk, Pootoogook, Eenutsiak came to our camp to tell us that Etidluie and his wife were ill. But they were too late; Etidluie was dead.

He was perhaps more than 40.

When the men had come back to our camp (after going to see Etidluie's wife), Mapaluk and my late brother Paulasie started off to Lake Harbour, our left-side neighbour, to trade with the people who had been riding and living on the "Active" and who in return had received ammunition and tobacco. Mapaluk took Kiakshuk and Eenutsiak as his helpers and Paulasie took Tukiki — he was quite a big boy by then.

On their way, they met Sila and Soo. Sila had brought with him all the goods to trade. My late brother Paulasie turned around and came back to our camp to help Sila with the goods. When they arrived it was dark. I thought the goods smelled very much of white men. It was because I did not get the smell of white men very often.

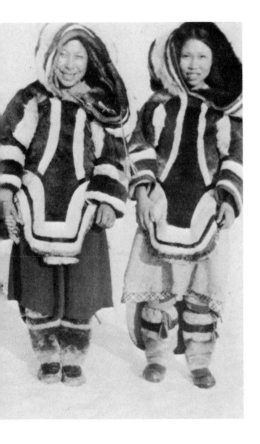

Sila was in the right place at the right time. He was there in Lake Harbour when the first Bay store* and houses were built. It was 1911. The men got rifles if they had goods to trade. Sila had enough foxes and polar bear skins to get a boat right away. When he came back to the Cape Dorset area — the right-side neighbours — he brought with him ammunition, matches and tobacco for trading. The Bay had supplied him with these goods to trade.

Sila and Soo came in 1912. Soo had for his wife, Mye, who was Koviantuk's real wife. That was the first time I found out that people traded their wives. That was their way.

I thought Sila was so powerful for he had so much property.

Sila had been going to Lake Harbour on the "S.S. Pelican," the Bay ship, and the Bay bosses were on the boat. There weren't enough campers in Lake Harbour and there were three boats in the Cape Dorset area. When the Bay found out that the Seekooseelamuit had so much fur — so much bear, so much seal — they asked, "Who's the biggest head around here?" Sila answered, "I am." The other people were quiet. We had never liked Sila because people thought him conceited. He thought he was such a big man. So Sila thought to himself, "I may as well say I'm the boss because all my brothers, brothers-in-law, relatives and other people are calling me a bossy person."

Before the Bay arrived, there was no real boss in an area. Each camp would have a leader — the biggest man and best hunter would be head. He'd be respected. After the Bay came to Cape Dorset, Sila became head of all Seekooseelak. He was the one who was taking care of what the Eskimo people were buying and trading, and writing down the accounts in syllabics. Before the Bay arrived, Sila was not the boss; after the Bay came he was boss almost until he died.

The white men made their own appointments. I was picked to be boss myself one time.

Sometimes the white men picked a man we didn't like too well. But up to today I have always thought that the white men picked a boss who could talk well, who had a good mind. The white men looked for the reliable man.

*The first Hudson's Bay Company arctic post for the promotion of the white fox fur trade with the Eskimos was established at Cape Wolstenholme in Arctic Quebec in 1909. Expansion of company activities north through the eastern Arctic followed and the Lake Harbour post, the first on Baffin Island, was established in 1911. It was HBC district headquarters for the Hudson Strait in the first days of the eastern arctic fur trade.

Kenojuak in the early '40s just after her
first child was born.

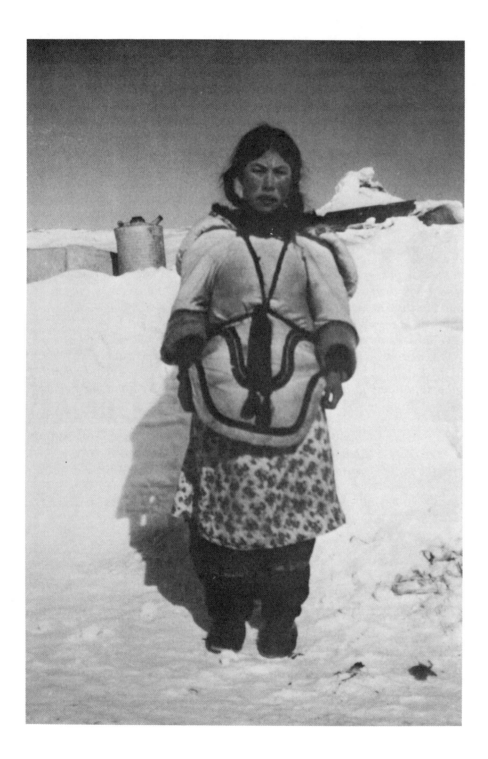

Johnniebo, Kenojuak's husband and
brother of Aggeok, who died in 1972.
He authored many Cape Dorset prints,
some of them mistakenly attributed to
Kenojuak.

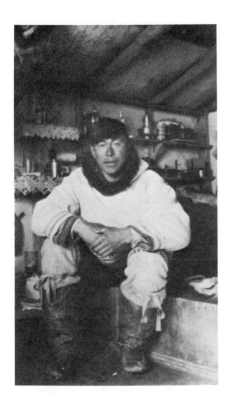

*When the ship came, the chief of each camp would always be the first to
trade. If the ordinary man came to the Bay, they would refuse him because
he was not the camp chief. And Sila was always the first to trade because he
was boss of the area.*

In 1912, in the time of the long days, William Ford became the first boss of
the Bay store in Lake Harbour.

My brother Paulasie went to get some white men's supplies. Right away he
was able to get what we called a "singable" – a record player. When I saw
the singable for the first time, it was able to do the unbelievable. I had heard
before about the record player because it was seen on the "Active" when we
were brought back to our land from Toojak in 1908.

My late brother Paulasie was the first real Inuk to own a singable in
Seekooseelak.

On his way home my brother brought with him Kenojuak. Kenojuak's wife
was Koweesa, the daughter was Seelaky*, the son was Tikituk. Tikituk was
being carried on his mother's back. Kenojuak and Takatak had been brought
from Aveeleek by the "Active." Takatak's wife was Angnashook, the son
was Koopeeooalook, the daughter, Koomaluk. Takatak's mother was
Niviaksee. Niviaksee had with her a grandchild, Nuvolia. I have heard that
the reason Koweesa came to our side was that their relatives had died from
starvation in Aveeleek. That was in 1911. Seelaky and Tikituk have been
here a long time now. Now it is 1972. They have been here on Baffin Island,
this giant island, lovely land, for a long time now. It is here they have grown.

Now I'll tell another story of the Cape Dorset area. After the new store was
built at Lake Harbour and people were going back and forth, we heard that
Meesagak, a white man who was a boss for the ship's captain, and others
were lost at sea. They had left in 1911 from Seengaiyak, beyond Frobisher
Bay, and had not returned. We heard that Ohituk, Ottochie's son, was one of
those who were lost.

*Seelaky became the mother of Kenojuak, author of *The Enchanted Owl*, the most prized
of all Eskimo prints; Tikituk, like Seelaky a carver and early print-maker, married Lucy,
another well-known graphic artist. A brother, Niviaksee or Niviaksiak, born later on
Baffin Island, made some of the most spectacular and valuable of the 1959 first-
catalogued edition of Cape Dorset graphics. He died after a mysterious encounter with
a bear.

Overnight caribou hunting camp in
spring.

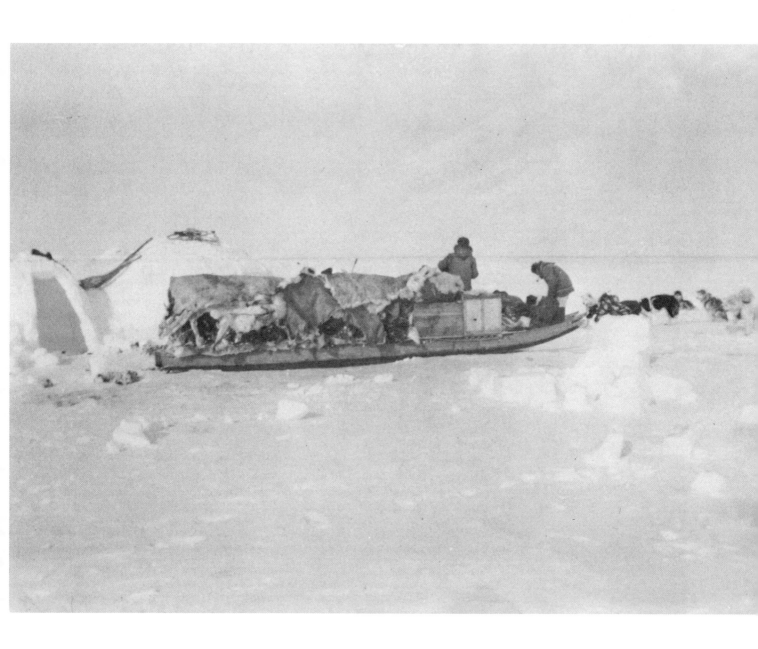

It turned out that Eskimos and white men were on a ship wrecked at Toojak — Nottingham Island. All the white men were lost.

This ship was going after polar bear, walrus and other animals. I don't know if they were after whales as well. The ship was a hunting ship. *

The ship touched a shallow area and hit rocks. The captain was watching only the walrus that were nearby. He did not see the shallow area; he was busy watching the walrus and not the water.

Before the wreck, the ship had gone through Kangeesookadlak — Cape Wolstenholme. She was not to return again. At that time Cape Wolstenholme already had white people living there. Some were on their way to Toojak when they lost their lives.

Before the ship sank, all the Eskimo people were told to go to the land. All the walrus hides were taken to the land and most of the ammunition — there were two boxes of ammunition and two boxes of tobacco. The two boxes of ammunition saved the people; it was a good thing they were taken ashore.

When the ship hit, the Eskimos told the white people the ship was split in two; the white people said no. Maybe it's true about the white people laughing at the Eskimos for being afraid. It wasn't so serious to some of them. They sank the anchor and tried to get free of the point where they were. Eskimos were running back and forth lightening the ship. Then the anchor wasn't under water any more; they couldn't get off.

The white people told the Eskimos to go ashore because they knew they were scared. They got some men to take the walrus blubber to the shore and some tobacco and two boxes of bullets so the ship would be lighter — just to prevent the ship settling deeper. One young white man got into the boat with the Eskimos but he was told to come back. This young fellow had put a lot of biscuits into his pants and pockets. He was stiff from biscuits. He was such a young man, he was scared.

The Eskimos asked the white people to go ashore but they refused. They were not scared because they had a boat on the ship. It was tied to the ship by a rope but they forgot to check to make sure the rope would not wear.

As soon as the storm arrived, it wore away. When they hit the rocks the weather was fine but in the night a storm arrived and the ship was pulled away.

*The Dundee whaler, "Seduisante."

The first HBC house, built in Cape Dorset in 1913.

During the night it became very stormy, snowy and windy. There were no tents – the Eskimos were sleeping outside on the ground without tents. Just as the dawn was coming up they heard shots coming from the ship. That was the signal for the Eskimos to get down to the ship. The white men were signalling for help. The ship was sinking.

The people started to go to help. But they couldn't row because it was so stormy. Of course there were no motors at that time. The wind was coming towards them. The Eskimos on shore kept trying to go to the ship but they couldn't move. They kept arguing about why they couldn't reach the ship. They tried, one after another, but they couldn't move.

The ship began to roll under the water. As it started to list the white people ran to the higher side. Waves washed the ship and every time a big wave covered the ship there were fewer left. At last there was only one. Even though these big waves covered the ship this one man stayed for a while. Then he was gone.

As soon as they knew for sure that all the white people were gone, Nuna wanted to share the ammunition and tobacco with the people. But he didn't know that one Eskimo, Meagojuk, had already taken some of the supplies. Nuna asked, "Who took some of the ammunition and tobacco?"

Meagojuk had taken the second box of ammunition and some of the tobacco. He hid them.

Meagojuk had been the aveeliak – the wife-sharing partner – of Meesagak, the white boss for the captain of the ship. He thought he could do whatever he wanted because he had shared a woman with a white man. Nuna and Joanasie were the white people's Eskimo bosses; Meagojuk was just a bossy person. Like his nephew, the poor late Tudlik, he was not very brave.

When Meagojuk knew all the white people were dead, he hid supplies for himself. He got the most. What was left was shared by the others.

Nuna did very well. Even to those who had no guns he gave bullets. He said, "We all can eat so I am giving ammunition even to those who have no rifles."

Two dead men were found. One had crawled onto the shore – his tracks were seen. The other was thrown on the rocks – his head split open.

After the men were found, one of the Eskimos tried to take the clothing from one of them. He was stopped by his mother. She told him, "These clothes

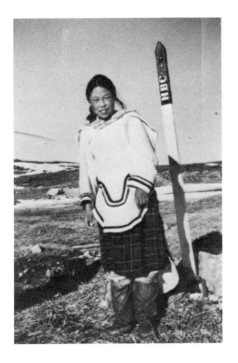

Ikuma, wife of Kovianaktoliak Parr,
beside HBC marker.

*belong to this man. If he were living he would not give them to you. Don't
take them now he is dead.''*

It is known that these men are buried at the tip of Toojak. My brother
Eetoolook once saw the graves when he went for a walk.

When spring came, three wooden boats and a fourth, homemade, sealskin
boat landed from Toojak.

Joanasie, Toogataguk, Lukta, Jamasie, these were the great men who came
in a homemade boat which Joanasie had made. With them were Joanasie's
wife, Seeta; two sons, Joanasiarak and Inuk, a little girl, Seetaralak; Lukta's
wife, Pooneeseetee, their son, a young man, Newjaliak; their daughter,
Samonie Natani; Toogataguk's wife, Kivaloaktuk. These were the people
who came in a homemade boat from Toojak.

The people who came from Toojak after the time the big ship sank were 61.
I did not see them all. I only heard of them. Maybe I missed some. I only
saw Joanasie and his group.

In 1911 they did not return but in 1912 they landed.

Next winter when it was 1913 William Ford, the Lake Harbour Bay post
manager, and his guide Esoaktuk visited our camp at Etidliajuk. He said that
when summer came Kingnait — Cape Dorset — would have white people. Ever
since there have been white people at Cape Dorset.

For a white man, Willie Ford spoke the Eskimo language really well. We
were amazed. He spoke truly the Eskimo way.

*He was the first man to tell the Seekooseelak people that the white man
would come to Cape Dorset. He stayed in all the camps for a while buying
fox and polar bear skins. We were very happy.*

When Willie Ford was on his way back to Lake Harbour, Mapaluk and com-
panions who had been there for supplies passed him on the route. That
springtime, Mapaluk went back again to Lake Harbour to get the boat he had
bought. That time he came back with his brother Ottochie. Ottochie had
returned to our land. He had been in Seengaiyak, near Frobisher Bay. He
went to Seengaiyak in 1909 and came back in 1913. Ottochie, Timungiak,
Ohituk, Napatchie, Kudluk, Pitseolak — these were the people who came.
Kavavow did not come with them; he was trying to get a wife.

Peter Pitseolak took this picture in the
early '40s from the roof of an HBC
building in Cape Dorset during 'umi-
akjuakkanak' – big-ship-time. They
are waiting for 'palajut' – throwing-
catching – to begin. The HBC paid off
casual labour by throwing dried food,
candies, socks, tobacco and other items
from the roof. People in the camps also
celebrated in this manner when a boy
caught his first animals.

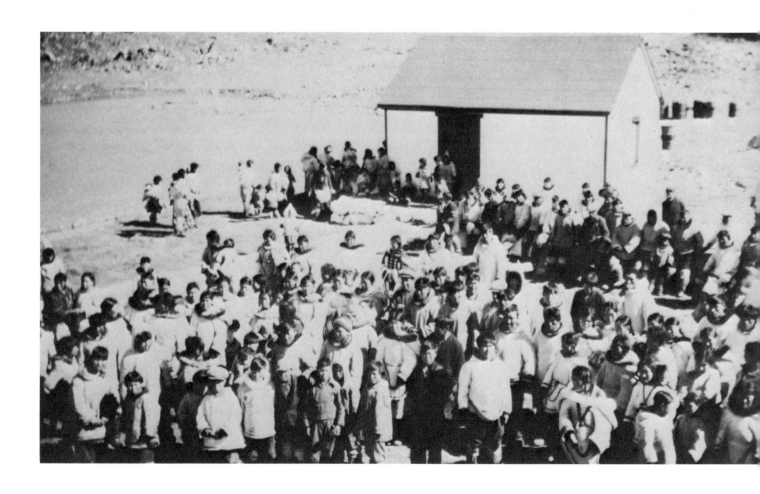

I will go on with the story. The big boss, Ralph Parsons,* the district manager from Lake Harbour, came to our camp at Elojuat in 1913. He was on his way to put up foundations for the houses that were to be built in Cape Dorset. He came on the Hudson's Bay Company's ship, "M/V Daryl." The people were happy because he traded with them and said there would now be white people around. His interpreter was Ben Pallister from Labrador and they took Keeriapik to guide them into Cape Dorset to put up the wooden frames.

The Inuit moved to the bay, across from Cape Dorset, to wait for the ship, "S.S. Pelican." There, a big caribou buck was seen and Pitseolak Oojusee-look killed it.

There were five camps at that time. There were maybe close to 200 people! It was the first time they had all come to Cape Dorset. 'Ahalona!' They certainly had a good time, waiting for the ship.

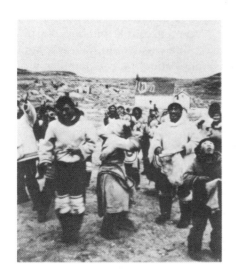

When we had been there a while, I became very ill. I almost died — still, I didn't. But I was very skinny and I did not eat for a long time.

It was when I was just a little better that people shouted with joy that many whales were entering the inlet. They were shooting at the whales when suddenly the big ship became visible from the point where the Catholic Mission used to be. That was in 1913. The many whales were soon forgotten when the big ship arrived. They were so happy about the big ship coming. My father said he was the only one left to cut up the whale meat. All the others had gone to greet the "Pelican."

Sila and Keeriapik were on that big ship. They were the first to bring the white man to Cape Dorset. At that time I wished I could put on my clothes but I was still sick, just getting better. The "Pelican" was the first Hudson's Bay boat that came to Cape Dorset.

Then the building of the new store began. It is still standing today in 1972. It dates from the time when I was eleven years old and I am now 70. The store was the very first building. Then I was only a little boy, as were Ottochie and Kavavow. While the old store has been standing there I have grown old.

*In *Trader's Story* (Ryerson), J. W. Anderson describes Ralph Parsons as one of the outstanding personalities in the recent history of the Hudson's Bay Company and the man responsible for the development of the fur trade with the Eskimos of the eastern and central Arctic. Parsons became the last Fur Trade Commissioner of the HBC.

Our first drawings were done with a jackknife and a spoon on windows. When the window was frosted – the window of a building – the frosted window was scraped with a spoon. We would put the spoon in our mouths to make it warm; then we would draw. That was how it was done when we were still real Eskimos. We were not told by the white men to draw; we did it by ourselves when we were children.

Sometimes the white men would visit the Eskimo homes. We had one such visitor. Sila's mother, Peeoliak, was trying to talk to him: she was telling him that I was sick. Peeoliak said, "The chest is hurting." She did this by touching the white man's chest. The white man gave her a piece of copper. He was making signs with his index fingers, as if he were making a hole. He was understandable even when we could not understand. He seemed to tell us that we could use this piece of copper for a necklace if we could make a hole. That was easy to understand. Kowmadjuk went out to get an interpreter; she was Annie Keemilu. She was Peeoliak's 'kreetugakatiga' – they had adopted children from each other. She came. She understood all right. After all she was picked to translate. She said, "When the poor little chest starts to hurt, put this piece of copper on his chest." She was wrong. She wanted very much for the others to know that she understood. She was just like us who could not understand.

Because I was sick I wanted to believe her and did what she told us. I used to put that piece of copper on my chest. All I got out of it was smelling of copper and I didn't get better from it. No wonder, it was just a piece of money.

Annie Keemilu had been in the white men's land; that was why everyone thought she understood the language. She was just like us; she could not understand. She was there for one winter; she didn't go to school. I am not criticizing her, I am just telling something that happened.

From this time on, except for three years when the manager wasn't good to the people, we always came to Cape Dorset at shiptime. The first white people were very good – at Christmastime they would get on the roof and throw tobacco and candy to the people. At shiptime, after the people had helped unload, they would give out food and other things – if people wanted nails they could take as many as they wanted.

People didn't do "work" until the Bay came here. Since they got paid, they liked it.

When the "Pelican" was to go away, the late Eegyvudluk was picked to be the Eskimo guide and helper for Willie Ford when he left for Cape Wolsten-

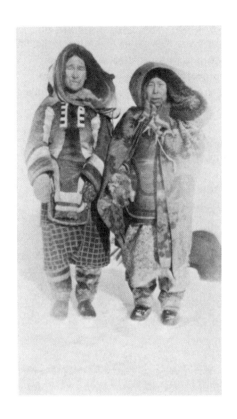

holme. Eegyvudluk said no. One of his reasons was that he could not bring his wife and family. They were to be all men. In his place the late Ottochie went with Willie Ford. He went by himself; he left his wife. He was away for one winter. A might-have-been clerk and a might-have-been interpreter were left behind here in Cape Dorset. And the "Pelican" went on its way with Ottochie on board to spend the winter at Cape Wolstenholme. They were all men.

Then a small ship came. It brought the boss-to-be to Cape Dorset. Hayward Parsons, Ralph Parson's brother, was the first boss in Cape Dorset. His clerk was S. J. (Lofty) Stewart and the interpreter was Johnny Hayward. Hayward Parsons was a good boss.

When winter came Nuna and his son Tapanni came from Lake Harbour carrying the mail.

The mail used to leave Lake Harbour with Lake Harbour people taking it to the nearest camp. Then that camp would take it to the next camp. The last camp in the Lake Harbour area would bring it on to Cape Dorset. Different people would bring it. Maybe three times or four times in winter and maybe once in summer by Peterhead there would be mail. Eskimo letters were folded like envelopes. They were on one sheet of paper and folded up and tied with caribou sinew. People would make them very tiny. They weren't put in mail bags . . . people carried them in their pockets and they became very dirty from tobacco. Sometimes you could hardly read the addresses. Everybody could write in syllabics — though some not so well. Some used to make very crooked letters and they didn't care about even lines.

Before Reverend Peck brought reading and writing to the people, travellers to camps would take messages. A man would say, "Tell this person I am fine," and when the messenger got to the camp he would say, "Tikaleegook" — he is there.

From the mail carriers we received the news that there were houses being built at Kamadjuak. The people who got the houses were the moving-picture makers. The year was 1913 when the houses were built. The picture makers came from Lake Harbour way before Christmas when it was a brand new winter.

The boss was Robert Flaherty. We called him Koodjuk because his flesh was white.

The moving-picture boss got Noogooshoweetok, Joe, and Attachie as Eskimo guides and helpers. The real worker was Joe's son Avaleeniatuk. He was just a young man, Avaleeniatuk. Attachie was their dog team driver. Noogooshoweetok was the one they took pictures of — and he also made pictures for them. Noogooshoweetok was the first one to draw; the picture makers made him draw.

I have seen Noogooshoweetok's drawings recently in books. He was my close relative. I remember he told me it was tiring to make drawings. *

The picture makers spent one winter amongst us and then they were gone. That time they visited us they helped the Eskimo people. Some got rifles from them and also many small things.

When Happy Time — Christmas — came we went to Cape Dorset to celebrate. There were no dances as the house was too small. There were races on the ice for men. Kavavow Ottochie was the first in the men's race; Sila and Kovianatuliak were next to him. They were side by side. In the women's races Seeta was the first one, Mooatee was next to her. When we children had a race, Joanasiarak won the race.

After we celebrated, we left. On our way home we stopped at Edlojuat, two hours by dog team from Cape Dorset. When I was told that I was to sleep with the old lady, Sheojuke, I hated the thought. It was only to keep me warm that Sheojuke wanted to sleep with me. I had never slept with another but my mother, and refused to sleep with Sheojuke. My brother was ashamed that his brother should refuse; he hit me. Then I had to crawl into Sheojuke's side. Sheojuke was eager to share the bed and I was not.

The next day we were travelling again.

I will tell another story.

My two brothers went to their trap lines around Nowjakudluk, on the islands near Ikirassak. My mother and I went with them. While we were there the picture makers came from Kamadjuak. There were two white men. One was the boss and one was the interpreter, Samuellie. The interpreter could not speak Eskimo. He had told them that he was able to speak the Eskimo language but he could not. That was why he was along on this trip!

*Noogooshoweetok's drawings can be found in *The Story of Commock the Eskimo*, as told to Robert Flaherty, edited by Edmund Carpenter, Simon and Schuster, Inc. His name, which in English means 'everlasting,' is spelled here 'Enooesweetok.'

The other people with them were Attachie and Simonie. After they reached Cape Dorset, Attachie and Simonie went back and in their place Elee was taken on. They wanted to go where there were many seals. They travelled on the ice, sticking close to land, but had to turn back at Alaveetook because it was too rough. The reason why they had to return at Alaveetook was because their guides had taken them over the hardest trail — they did not want to go for seals!

That's how I heard it. It must be true because on their way back they did not pass through our camp. They went through Keekeetajook in the Ikirassak area.

That's the end of the story. It happened in 1914. People tried to go to where the seals were but had to turn back. They got as far as Alaveetook, near Schooner Harbour.

Then Ralph Parsons, the big boss, came with two dog teams to our camp. He travelled with Eshoatook and Sagiatuk. Mallituk was leading on the other dog team and was first to arrive at the wrong destination. They were heading for our camp but they took the wrong turn because they had fog. Mallituk was afraid then of the big boss. When the guides told him they were on the wrong trail he insisted they keep on going until they reached Paulasie's camp. He very much wanted to reach Paulasie's camp.

When the sun was still low in the early morning they arrived. They had camped not far away.

When he went on to Cape Dorset he left food for my late brother, Paulasie. I got many candies and there was almost a case of cookies, many biscuits, tea, ammunition and sugar. He gave much food, mostly for my brother Paulasie.

Next Reverend Fleming whom we called Inuktahow — 'a new person' — and his helpers, Pudluk, Naligianik, Elijah and Yotie, passed through our camp. Elijah and Yotie were to turn back at Cape Dorset. Inuktahow, Pudluk and Naligianik stayed with us for a long time — they wanted to see all the people and the camps in Seekooseelak.

When Naligianik got sick, my brother Eetoolook helped Inuktahow. Then my brother Pootoogook went with him to help when he left our camp. He did not let my brother go until they reached Eemeeleegajut. He wanted to keep him as he was a good worker. He was a fast worker when they had to make

Kooyoo on a chilly day.

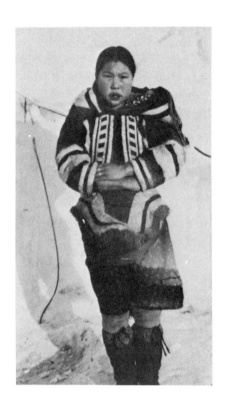

'iglooveegak' — snow houses. He and Pudluk finished iglooveegak very fast. He and Pudluk were very good together; he wanted to keep them both and he did not let them go for quite a while. Pootoogook was to turn back home when they reached Teekot near Shabuk but Inuktahow did not let them go. Pootoogook did not come home for a long time.

In spring, the people from Cape Wolstenholme came to our side by the "Ivik." Willie Ford and some helpers passed by our camp at Toolookat. They were going to Lake Harbour. Their boat was a Peterhead, the "Nova Scotia." Toogataguk, Paulasie, Jamasie, they went along with him to Lake Harbour.

When we went to Dorset to pick up supplies, Simonie and his companions at the Bay no longer had their interpreter. Our interpreter, Johnny Hayward, had gone to Cape Wolstenholme on the other side where they were building new houses. The Cape Wolstenholme people had taken him along as their helper.

We then went past Kageak camp. At that time my late brother Paulasie was in bad health. His lungs were gone. He could do nothing. He was dying there at Tikerajuak.

We had to be left behind there when he was unable to do anything — it was very sad after we had been left behind. We were so few. I was just a little boy. We had to go and bury him. My mother carried him on her back as she was the only adult person who could carry him.

My father was then too old and sick to carry him. Paulasie's wife could have done this but she was scared — she was scared of Paulasie.

Whenever I think of my mother I always remember her carrying her dead son and I love her.

I am telling this story which is not very happy about the year 1914 when my brother Paulasie died.

When we returned from the place where my brother was buried we stopped in Ottochie's land — Satoretok — on our way to Cape Dorset for supplies. Ottochie had a new boat. Also, Elee and Meelia had bought boats at exactly the same time. We also heard that our boss, Hayward Parsons, had gone.

His clerk, Lofty Stewart, became the boss. His Eskimo name was Angootee-kootak — meaning 'a tall person.' He did not have an interpreter though he did not know any Eskimo. That was the time, too, when we heard that Patchow and Mattee were on the "Pelican." They had moved to this side of the land. Also Shoo and his helpers, Sheaqajietuk, Kalie, Paolassie, had come from Toojak. They also had moved to our side.

We spent the winter at Etidliajuk. We were a great many people. In the new winter, long before Christmas, Satie, Kakajuk and Simonie stopped over-night at our camp. With them was Johnny Ebert, who became our interpreter with the Company. He had a white father. We called him Kareeshak — 'the brain.' Satie was taking them to Cape Dorset from Eteenik, near Lake Harbour, to spend the winter. Kareeshak Johnny — the brain — was very young. He did not stay in Cape Dorset very long.

At Christmas we went to Cape Dorset to celebrate. Satie and Kakajuk were on their way home between Keatuk and Cape Dorset after crossing the bay. They stopped so many times, crisscrossing other dog teams on their way to Cape Dorset.

That time in Cape Dorset there were many people celebrating. They are no longer living today. When they were having the dances I so admired our new interpreter — Kareeshak Johnny. He was a great dancer. Our boss was fiddling and his washer, Mary Koolularaluk, was playing the music box. (When Koolularaluk became the washer and our boss no longer wanted to call her Koolularaluk, he named her Mary.)

When they were having the races on the ice, that time the fastest runners in the men's races were Kavavow and Paolassie. When the women were racing, no one could ever keep up with Ineak. There were many women running behind her.

When it became 1915, the mail carriers arrived at our camp from Lake Harbour. They were Attachie and Pudluk. Attachie's poor dogs were very skinny. Attachie asked us, "Will you harness up the dulse 'comocks' — the seaweed fleas?" and everyone laughed heartily. It turned out that these dulse comocks (Attachie called them that because they were so skinny) were very fast even though they looked so poor. We ran and ran to keep up with them when we went to say goodbye. Attachie made fun of them but they just were poor and skinny to see; they were able to pull hard with their tails straight up.

Then Ralph Parsons, the big boss, travelled past on his way from Lake Harbour to Cape Dorset. Also Inuktahow, the missionary, passed through.

Pulling in a walrus. Many of the voyages of the Peterhead boats were for walrus which was used as dog food. Now that snowmobiles have replaced dog teams, walrus meat is not much in demand.

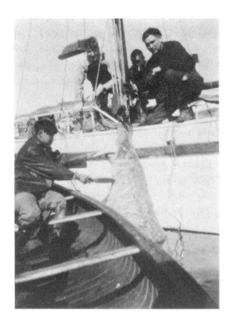

Inuktahow's helpers were Pudluk, Jallie and Kingwatsiak. They helped him for a little while and then were left at Cape Dorset when Inuktahow went travelling from camp to camp. Then people living inland, Meelia and Patchow, went to Cape Dorset to pick up supplies. I went along and Meelia had a polar bear baby as a pet.

When spring came people were hunting for walrus as Nurata, Sila's camp, had requested. That time the Hudson's Bay Company was after the walrus skin.

There were four boats hunting walrus: there was our family — Inukjuarjuk, my father, and my brothers, Pootoogook, Eetoolook, my mother and sister and sister-in-law, and myself; Meelia and companions; Eegyvudluk and companions; and Joanasie and companions.

A large boat, ''Meetik'' — the Eider Duck — also came on the hunt. It had a top but no motor, only a sail. When they didn't get anything here, that boat went to Toojak, to the spot where the high hills are, to get the walrus hides Sila had ordered.

Elee was the acting boss. They were using the kadluna's boat and it had a top.

Alariak joined them in Toojak. Alariak's wife was Echalook, their daughter was Tayarak, their sons Amarook, Oshooajuk and Inujak. These were the people who got on the boat at Toojak when it was 1915.

Alariak had been a shaman but he gave it up before he came to our side. Dr. Peck told the people they shouldn't be shamans and Alariak heard it from the people. He was a real shaman though. People know it. Mapaluk used to tell many people about the things Alariak could do.

Once Alariak told me his story.

Alariak, my cousin Mapaluk, and another man (whose name I don't know) were caribou hunting. They saw one caribou — an excellent one. They had their guns and each wanted to be first to shoot this tuktu. But Alariak said — and he was smiling — that he wanted to test his powers and kill the caribou with his spirit. Of course, Alariak knew that shaman people could kill other people with their spirits. Alariak was a good shaman but some shaman people were very dangerous. So Alariak wanted to test. The three men were sitting waiting — the caribou was coming towards them. It had to pass

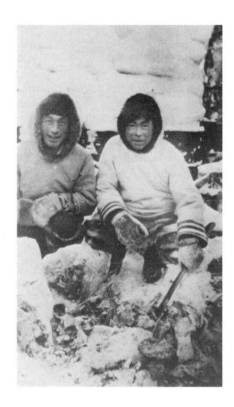

behind a hill and as soon as the caribou was behind the hill Alariak turned around in the other direction. For a few minutes he didn't say anything. Then Alariak told the two men the caribou was dead. He said they should go to the tuktu. The two men saw it – dead. Mapaluk was amazed. He told many people about this.

Alariak told them they could take the skin – half and half. He didn't want it, he might die if he took it. They took the skin but the insides, the intestines, the lungs, everything, had turned to blood. They didn't take the meat.

Alariak told me he had two spirits working for him – a dog and a spirit called Mikeajook which means 'fur in the mouth.' Mikeajook was a human being. He had no teeth but a lot of fur, inside the mouth as well. When I asked why he had fur inside his mouth, Alariak said it was ''because he was Mikeajook.''

Alariak told me about his journeys to the bottom of the sea. Whenever people in the camp were hungry he'd go underwater to reach the beautiful lady at the bottom of the sea and find food. When the shaman made this journey he'd have to sing songs to his spirit.

The path to the bottom of the sea was very dangerous with smooth and very slippery ice. The reason the shaman went was to bring the animals close to where the hunters were. Along the journey there were many animals. And all around the beautiful lady the animals were thick as flies. They looked like a mass of insects clustered together. This lady had so many animals – the usual animals, most of them food animals, the sea animals and, yes, the tuktu, too. All kinds of animals. She was the goddess of the animals.

After Alariak had made this journey, the men would go out hunting and they would find food. Alariak didn't actually get the food from the lady – the men would go hunting and they would find food. The men had to hunt for it but they would catch food for sure.

Like we pray in church, Alariak would pray. Once when the Anglican clergyman from Frobisher Bay was taping Saggiak and me, Saggiak sang some kind of song about the beautiful lady and the animals. I was quite ashamed of Saggiak for singing this song. Then he said, ''I went dizzy because some people do go dizzy.'' He started to laugh. All that was taped. When we heard the tape we were all laughing.

It wasn't Saggiak's own song. He had learned it from someone. It was another shaman's song – not Alariak's. (Of course Alariak was not the only one who knew that lady, the goddess of the sea. Other people knew how to

make that journey.) Saggiak was singing the song of a lady shaman trying to get seals. He was singing a song he'd heard about a shaman lady praying for food through her spirit.

When he sang about the beautiful lady at the bottom of the sea, he called her, Mother.

I don't know if the goddess at the bottom of the sea is Talilayu. She probably is. There's a story about a young girl who was mistreated and put on an island. A kayak came along and she tried to get into the kayak. Although she was told to get her hands off she kept clinging onto the kayak. When she wouldn't listen, the man chopped her hands off with a knife. She went under water and lots of seals drifted up. People say her hands became the sea animals and her body became Talilayu. It's probably not true but it's a story.

Cape Dorset people probably were able to make the journey to the bottom of the sea too . . . because, well, some people were shamans. But I never heard about it. I only heard about them punching the arm muscles because they wanted the weather to turn good.

Takeassuk once told me a story about the half-whale woman. It's a true story. She was shot by Indians. They thought they'd hit a seal. After they shot her they went to look at her and they saw the hair braided. Half of her was some kind of whale or fish — there was a flipper — and the body part was human. The Indians started shouting, "We're murderers, we're murderers." They buried her on the land. Probably her bones are still there in Arctic Quebec. I think Takeassuk told me it all happened somewhere near Great Whale River. He didn't say how many Indians killed her; he just said Indians. Probably an Eskimo was along. Takeassuk only heard it but it happened recently, less than 100 years ago — probably when Takeassuk was a boy.

Another thing: Johanassie Apalirak from Povungnituk told me he thought there really were Talilayus — that they may not be just fairy-tale stories. They may be true. Apalirak told me a story about a man who lost a son at a camp where several men had disappeared. This man was forever hunting, probably looking for his dead son. He was hunting one day with another man when something got hold of the tail of his kayak and tried to pull it down. These men tested. They put their kayaks back to back and watched to see if something came up. Something did. The man harpooned it and while the creature was struggling under the water, trying to get free, there was a lot of crying. Real cries. Then the creature died and got lost. The men didn't even have a chance to see what it looked like. But they heard the cries of a crowd of voices — from the bottom of the sea. All the crying must have been other Talilayus.

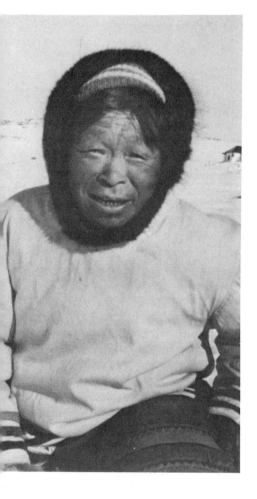

Takeassuk. A native of Arctic Quebec and a fine sailor, he moved to Seekooseelak when he piloted Peter Pitseolak's Peterhead the "Qairulik" on her maiden voyage across the Hudson Strait.

After this the man thought that's how his son was lost – probably eaten by this kind of animal.

Pootoogook also saw something once –he didn't know exactly what. He saw it from a distance when I was young. Maybe it was Talilayu. He thought he'd seen a seal but when he got close he saw arms waving. That was no seal.

Yes, I think there are many animals in the sea that we don't know about. Ahalona! I certainly know of the sea dogs. We have even seen them in Cape Dorset and Lake Harbour. They're real dogs. We've seen the tracks; they're bigger than those of dogs, about the size of wolf tracks. Once people saw three dogs together on the beach. These dogs rushed to the sea and dived in; they disappeared. I have never seen them myself but Pingwartok from Cape Dorset who is dead now saw one. He was working with his net getting fish. All of a sudden he saw a whitish dog walking along the bottom. It seemed to be on the land, even though it was in the water. It was eating the sea weeds.

When everyone on the walrus hunt had enough walrus hide we headed back for Cape Dorset. When we reached Cape Dorset we saw the big ship, "Nascopie." This long ship was anchored when we saw it. Our people were giving warning shots. I was so happy that my hair seemed to jump up and down. It was the first time I saw the "Nascopie."

When we landed at Cape Dorset, I saw many people I had never seen before. It turned out that these were Commock and companions.* They had come from Toojak with their live, polar bear pet. Commock and companions were told to go back to the ship. They had intended to stay and live. They were much disappointed when they were told to go back where they lived before. They had lived at Cape Wolstenholme; they had wanted to move to this side of the land.

That time when I saw Commock and his people was also the first time I ever saw white women. There were three on the "Nascopie."

I have heard of many but this Commock was the bravest of all hunters. His son, Peter Ussie, told me the story of how he tried to come to live at Cape

*A version of Commock's story can be found in *The Story of Commock the Eskimo*, as told to Robert Flaherty, edited by Edmund Carpenter, Simon and Schuster, Inc.

95

Launching Peter Pitseolak's boat in
Cape Dorset in the late spring.

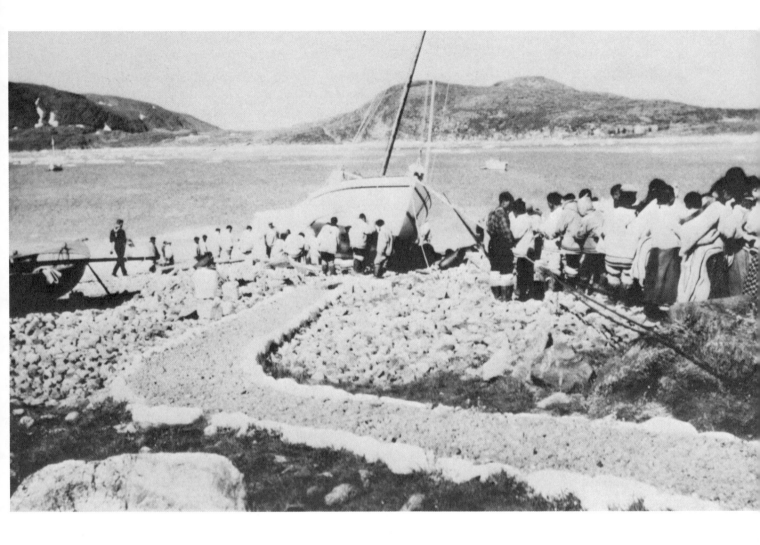

Dorset when I was in Toojak — Nottingham Island — in 1927. Peter Ussie is dead now but his daughter is in Frobisher Bay. She's Mrs. Karl Kristensen — she's married to a white man.

Commock was trying to come to our side. He had lived in the area of Cape Wolstenholme but he went away from the Quebec mainland because his young brother shot someone. Then the same rifle his young brother killed with shot another in an accident. Commock put it on the ground and it went off as he put it down. It was an accident. Everyone was nice to him but he was worried. He left with his family.

They went away from the Quebec mainland to Pudjunak — Mansel Island — and they were there for the whole summer. They were wearing polar bear skins there — the only clothes on that island. They were there for the whole summer and they tried to move on in winter. They wanted to go to Dorset so they tried to reach Toojak — Nottingham Island.

They almost did. They walked over the ice and arrived near Toojak. The water there is always moving. It never freezes. Commock knew. He stepped onto the ice floe on purpose, thinking the current and the winds would push them to Nottingham.

They were so close to Toojak that Teevie, whose son Jamasie is the print-maker here in Cape Dorset, could see them on the floe in their polar bear skins. He didn't know if they were polar bears or human beings. He told everybody back in his camp that he didn't know what they were. He didn't try to reach them.

These are the people who were on the ice floe: Commock, his wife, his son Peter Ussie, his son Ussie Sanak Nanook, three daughters, and little baby, Thomasie Mangeok — he's a preacher now at Ivugivik. They slept on the ice floe and in the morning the sea had taken them back near where they started from . . . to a little island, Qirkartasirk — Digges Island — off Arctic Quebec and Cape Wolstenholme.

They stayed on this island for many days. It was the beginning of spring — too late to cross the ice to the Quebec side. They weren't hungry. They found a dead seal, a big one, on the ice and the meat kept them fed for a bit and they took the skin to make some ropes to use on the cliffs to get near the 'akpa,' the murres. It was an island with many akpa birds and there were many eggs in the deep cracks. Commock's sons were helping him get the eggs. The akpa have big eggs — a little bit bigger than ducks' eggs — with lots of dots on them. They're colored like dogs — many shades: greens, blues, white and brown.

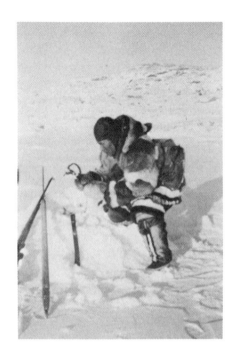

Peter Pitseolak demonstrating how to set a fox trap for the camera.

A second dead seal came and Commock killed another one – I don't know if he harpooned it or shot it; I heard from his son that Commock used to kill seals with a bow and arrow. Commock used the skins for a sealskin boat. He made it with driftwood he picked up.

They heard gunshots while they were making the umiak. When they heard the shots they knew there would be white people in that direction.

Maybe they met Robert Flaherty when they were in the umiak close to shore near Cape Wolstenholme but they didn't get a ride with him. But Flaherty and the Company gave Commock a boat because that umiak was not very good.

Commock told his story to Robert Flaherty in 1914, the year after Flaherty was down at Kamadjuak. I heard it myself from his son on Nottingham Island in 1927 or 28.

The next time Commock tried to come to Cape Dorset, he came by ship. He started in the canoe he got from the white people and then he got a ride with his canoe on a ship. He came to Cape Dorset while I was going after the walrus hides. He was there for a few weeks waiting to go caribou hunting inland. While he was there Ralph Parsons arrived on the "Nascopie" and Commock helped unload the "Nascopie." The big boss, Ralph Parsons, saw him. "Why are you here?" he asked. Commock answered, "Because I have come to live here." Ralph Parsons said, "Aga – no! You can't stay here."

The Eskimo wasn't so free in those days. This was because of the Bay – the Company didn't want people who didn't belong here to live on our side. Even Lake Harbour people, if they came without a letter, would be sent back to their homes. It was because of the fox – at that time they were going after fox furs. The Eskimos weren't very happy because they liked to move and live where they wanted. They didn't like it if a white person said, "You can't live here – you've got to move." But they were scared; they had to move whether they liked it or not. Otherwise they wouldn't get ammunition and food from the Bay. Some people had a choice; some didn't. The Bay people used to ask, "What are you doing here?" Some people wanted to move because they'd run out of food.

This was going on all the time until the Baffin Trading Company came in 1939. After they left there was a bit more of it but not so much.

Commock stayed on the other side. He didn't try again. He lived in the Cape Wolstenholme area and he had his main camp on Mansel Island until he died.

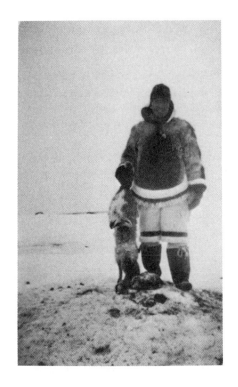

Peter Pitseolak with white fox.

Next we travelled north through Kageeshooreetuk with Eegyvudluk, Elee and family, and Namonie. Then we spent the winter at Etidliajuk.

It was that winter my father died. Attachie and his people had carried the mail from Lake Harbour. That time sickness was also carried by them from Lake Harbour. Olaegee and I became fatherless. Both our fathers died at that time, when we were just boys.

Eskimo people were very sick that year in 1915. It is a long time ago now that my father died. It was the year Angooteekootak — the tall person — who had no interpreter was the boss in Cape Dorset.

That winter we camped inland at Eisaveetuk, a long giant lake, with Patchow and Pudluk. When it turned 1916 and spring came, my mother, Kooyoo, and I went with Sila to the Inarooleemuit. When we went to pick up supplies, we stayed behind in Cape Dorset. Alariak came and we went with him to stay with my brother-in-law, Joe. Sadly that year, in 1916, my brother-in-law Joe died at Sapoojoak.

When my brothers came we heard that Willie had become the new interpreter for our boss, Angooteekootak.

Elee, his relations, and my family spent the winter at Etidliajuk. When winter came, Nuvolia — he used to guide the ships to harbour — came from Lake Harbour carrying the mail. With him were Epervik and Jallie. That was the first time we had seen Epervik. He was the son of Ashevak and Kudlajuk. He was a big boy then, almost a young man. He was a very goodlooking boy.

After the mail carriers went back to Lake Harbour, their boss, Hayward Parsons, arrived, along with Anakok and Satie as his helpers and dog team guides. Anakok was the adopted son of Ashevak. Anakok was a young man. Satie was also from Eteenik, near Lake Harbour. They came to our camp, Etidliajuk, to spend the night. That was in 1917.

Then came Ashevak, whose daughter was Aggeok, and son was Anakok. Ashevak's wife was Kudlajuk (Anakok was Kudlajuk's real son). Anakok did not come with his family as he was a working man in Lake Harbour. It is a long time ago now that the late Ashevak, my present wife's father, came to our camp.

My mother said even then I would marry Aggeok one day.

Aggeok and baby in the quarmak — a double tent over a wooden frame and floor. Frames were left permanently in position and covered at the onset of winter. The double tent was lined with bushes and then the quarmak was banked with snow blocks. ''Just the Eskimo seal oil lamp and it was warm enough,'' Aggeok says.

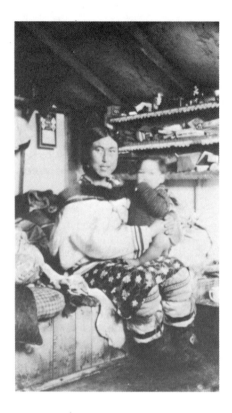

Then we spent the winter at Sila's camp — the further Inaroolik (there were two Inarooliks).

When the men were away walrus hunting at Nuvoojuak, a big male polar bear came to our camp. It was at night when it was very dark. It was very frightening; there were no men. I was just a boy. My mother woke me up; the dogs were barking loudly. That was a time I was shaking with fright.

I was scared. I thought I had put on my boots but on one foot I had only put on a sock. I did not even feel the cold water I walked through when we crossed a brook. Finally someone noticed I had on only one boot.

My mother wanted me to come with her to go after the polar bear with a gun. I said no because I was frightened but I went. It was very dark and it was also very cloudy. There was no moon.

The dogs were barking at him. As we went along, my mother kept telling me, ''Come, come, come,'' because I kept stopping. I was so frightened.

Then suddenly I was smelling rotten meat. The bear was eating the meat from the cache. The cache had rotten meat — it was for dogs— and the whole outdoors seemed to smell of rotten meat. The wind was coming from the same direction as the polar bear and the meat. We could see the bear eating at the meat cache as he stood out on the horizon.

My mother said, ''There he is!'' But I could not see him for a long time. When I sighted him I told my mother I would shoot at him but I could hardly see my gun as it was so dark. No wonder I missed when I shot. He ran away to the other side of the camp. When my mother and I could no longer see him we went back to the camp.

When it got lighter, I went to see what I could see.

I found him returning. He was once again eating at the cache. I went towards him. This time I did not care even though I was by myself, it was fully daylight — early in the morning.

When I shot him he looked as if he had never lived.

I shot at him from a very near distance. He was in a hollow and I had to go near him in order to shoot. I shot him in the huge head. He was my very first polar bear. That was 1917 and I was 15 years old.

When my brother Pootoogook, Epervik and I went to pick up supplies we found out that we had a new boss. He was Solomon Ford. He was very old. He talked Eskimo well. His clerk was called Noovoosiak — 'pointy nose,' in Eskimo. The boss, Solomon Ford, was called Eetorooloat — 'poor old man.' He was very old; he was hairless on his head because he was so old.

We spent the spring at Inaroolik, the one nearer to Cape Dorset; that was in 1918.

There Ashevak and Poolalik went up the hill to scan the land below them and saw polar bears — a mother with one cub. When they saw them running Ashevak and Poolalik ran after them. They had their guns and they ran towards the ice. We went along with them but they did not tell the rest of us — Sila, Pootoogook and me — why they were running or that they had seen polar bear.

We pretended to be seals on the ice. The polar bear was fooled and thought we were seals on the ice. He came towards us with his mouth opening and shutting. (I found that they do this to exercise their mouths.) His mouth would open very wide.

The bear was very close when Ashevak shot. When he shot there was silence only. He tried again — not a sound.

Then I shot. He was no longer living.

As soon as the bear was dead, my brother was scolding me for killing the bear. He said the bear was for Ashevak to kill. He was ashamed of me for taking somebody else's polar bear. Well, I got my bear that day. But I did not get the skin. I was told that Ashevak would keep the skin.

When he was told he would keep the skin he came to me and said, "My cousin, we will share the money I get from the polar bear skin. We will divide the money equally." He said that but it turned out that he was telling an untruth. We went to trade together but I never got anything. When he said that I would get my half he thought the business was completed. That was why he never gave me any money.

We went by Sila's boat for shiptime and to pick up supplies. We had been in Cape Dorset only one day when the ship we had come to wait for arrived. It was the "Nascopie." Our boss in Cape Dorset, Eetorooloat, was to leave. His clerk, Meelituk Noovoosiak, took over.

Summer tent outside Cape Dorset. Aggeok developed this picture in 1946. Left to right: Achiak, son of Kemirpik, Nero-katchiak, Pannichiak and baby (both now dead), Kingmeata and baby, Pannichiak's son Axaganyu, today a well known sculptor, and Kemirpik.

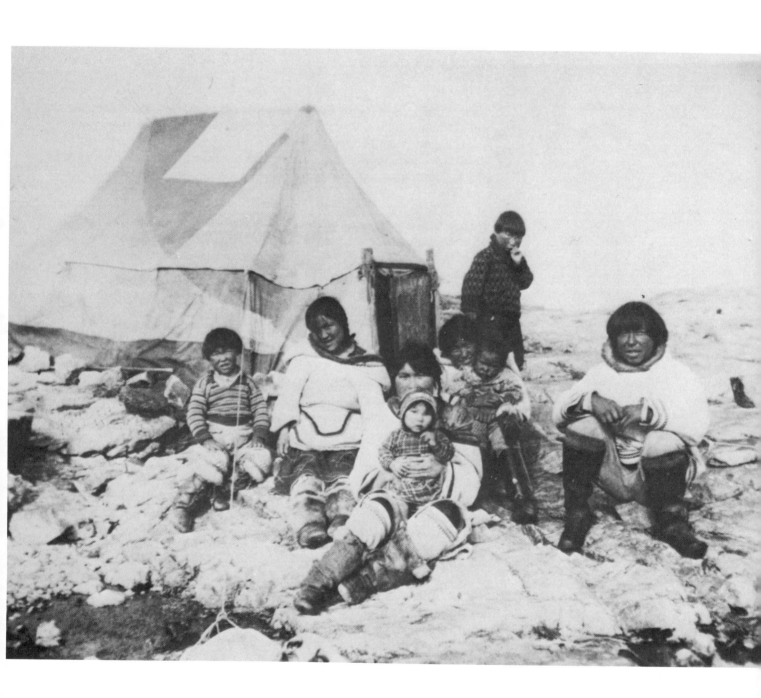

We spent the autumn at Inaroolik, the one closer to Cape Dorset. There were many of us. That time, when winter came and we went to pick up supplies, Willie, a white man, was the new interpreter at Cape Dorset. That was in 1919 when our people and Ashevak's people went to Cape Dorset. My brother Pootoogook had many fox pelts and he also had polar bear skins. We could not return to our camp because there was no food for the dogs at Cape Dorset.

Our family and Ashevak's family moved to Newleejutalik, near Cape Dorset. We were the only people there, our family and Ashevak's. My brother Eetoolook came after us to tell us that we had been invited to attend the Happy Time at Cape Dorset. Ottochie's sons Ohituk and Napatchie were at our camp visiting us at the time. They wanted to come with us although they had not been invited. They came with us.

When it was almost spring, when there were seals on the ice, we moved to Tikerak, near Satoretok.

When I was growing up and when the seals were on the ice, the way we hunted the 'ujuk' was by shouting. The Eskimo people used every easy means they could – the voice was one of the big helpers. To get really close to the seal, you'd shout. You had to make sure the fur was completely dry – if the fur was wet they'd run right back in the water. Then by shouting as loud as you could you'd confuse the seal. The loud noise would break his ears and make him deaf. He wouldn't go down. Once we went hunting for seals with a white man. When we saw seals I said to start shouting but the white man thought we were all crying! Even when I was grown up they were still catching seals this way. Even today I could catch one this way.

I was a big boy by now. I was a young person – 16 years old. At that time, if I had had a good gun, I could have killed many seals. But if one was an orphan, a gun was hard to get. Now I have many guns; I have ten guns. I wish one of them had been my gun long ago.

I am going to tell about the gun I had at that time. It was a very old gun – 44/40. It was bound together with string many times. After each shot I would clean off the soot. Ammunition was made then from soot. We had to make it up, then push it into the gun.

I envied those who had fathers; they had good guns. It turned out that in the future I would also have good guns. Because I always used to be envious of those who had better guns, I am always buying new guns today. I planned to do this when I would be able to afford to do things.

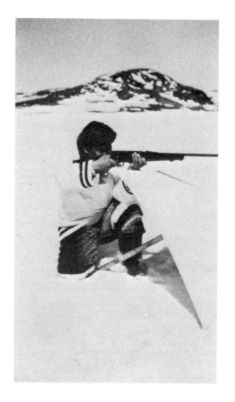

While we were at Edloojuak, boats came to our camp and my late brother Pootoogook went off in the boat of Ohituk and his family who were going to trade. He went to buy a new boat. That was his first boat. He bought it when Meelituk Noovoosiak was the boss at Cape Dorset. My brother bought his first boat when it was 1919.

When summer came we went to Nurata. We then spent the autumn at Nurataroosik — the little Nurata. When no one had killed any walrus, our companions, Sila and Pulalik, went to winter at Kayishoojuak. That's why we were left alone at Nurataroosik.

At this time Meelituk Noovoosiak was the only kadluna at Cape Dorset — there was not even an interpreter.

When the days got longer, we moved to Newleejutalik, near Cape Dorset. It was 1920, the year Ohotok took my late cousin Etidluie's daughter, Napatchie, for his wife.

Ohotok had taken two sisters, Ekateelik and Napatchie, for wives. Maybe when he was taking Napatchie, their brother, Kiakshuk, didn't agree with the idea so Ohotok gave his own sister Mary to Kiakshuk. He thought, "If I give my sister Mary to Kiakshuk, then Kiakshuk won't mind if I take his sister." But Mary was already married to Napatchie Ottochie — to Napatchie the son of Ottochie.

So while we were there at Newleejutalik, Kiakshuk took Mary, Napatchie's wife, for his wife — just for a little while. At that time it was doing wrong, but now people are doing much more wrong. There are so many now who are having children. They seem not to have a husband but they have children.

Napatchie Ottochie didn't like the idea; he wanted to keep his wife. He was trying to keep his wife but Ohotok and Kiakshuk wouldn't let him have her back. So Napatchie went along with his brothers to get his wife. My brother Pootoogook and Tapanni went also — just in case. If they started to fight, Pootoogook and Tapanni would help.

They took back Napatchie's wife.

Kiakshuk was a shaman and I've heard it said that Napatchie's death some time later was caused by a shaman, but I don't believe it. Napatchie was hunting near Sabarosek. He landed on a small island and his kayak drifted away. The island was too small — there was nothing there. He took off his

sealskin boots and turned them into floats and tried to reach the mainland but couldn't. He drowned. Before he left he built an inukshuk on the island. He made its arms point to the mainland. That inukshuk is there today. I saw it recently.

Later people found his boots and they found the kayak. There was still a piece of seal on the kayak to make it easier for the paddle to move. People wondered why the foxes hadn't eaten the meat. But I don't believe Napatchie was killed by a shaman. It was a hunting accident.

We spent the winter at Etidliajuk. At that time we got a new boss, William Pennell. Sowmik, the 'left-handed one,' as we called him, became the manager at Cape Dorset. His interpreter was an Eskimo – Peenieja Neegeokudluk. When Sowmik and Neegeokudluk were new in 1921, that was when Oshoweetok Ohotok was born at Newleejutalik. He was Ohotok and Ekateelik's very first son.

When the days got longer we went to visit our left-side neighbours and went walking-hunting through Kinguk – Markham Bay. We camped where there were a few caribou – there were not many but there were times when we killed caribou. There were some caribou on the hilly land, but when we got to the flat, smoother land there were no caribou at all. For some days – not too many – we were almost hungry. But we moved to another plain further on and there we killed many caribou and were no longer hungry.

While we were being lucky enough to kill caribou we ran into Malakie, his wife, Eegyvudluk, their adopted children – there were two – and also Savik and Kimipiajuk.

When it had begun to get dark Malakie and Eegyvudluk had heard shooting. They didn't know there were people around; they thought there was a ghost. But my brother Pootoogook had shot and wounded a caribou by moonlight. That was why they thought there was a ghost – because of the dark.

Pootoogook met them next morning but I was taking the rest of the family walking-hunting inland. After we had been away one night we met them, too. Pootoogook had arrived when Eegyvudluk was still sleeping. Malakie didn't want his wife frightened and when he saw him coming he ran to his sleeping wife to wake her but Pootoogook arrived first. This was the first time we had ever seen these people. They were Ikalumuit – people from where there are fish. They were walking-hunting from the Frobisher Bay area.

Ashevak and Kooyoo going out on the
land.

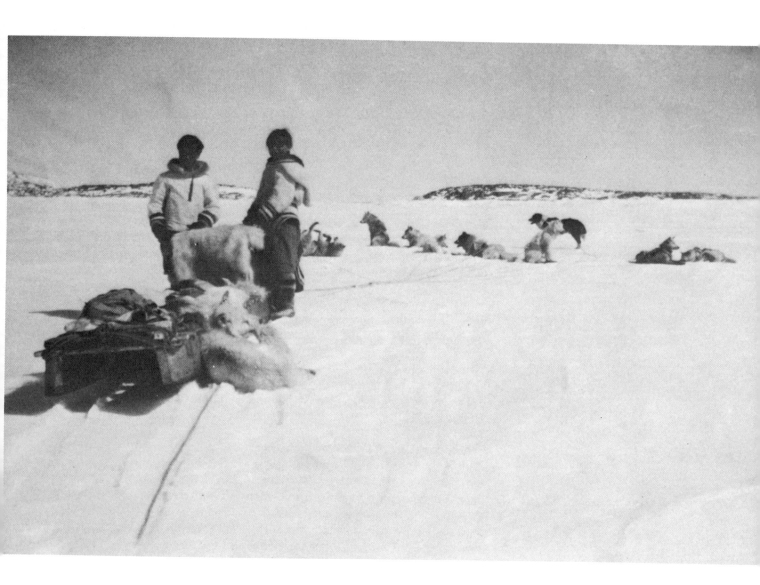

After we met them, we camped near Lake Amadjuak. There we killed caribou to our content. While we were still able to carry all the skins we went on our way back to Markham Bay. Those others who were spending the summer inland with us went hungry. They were Simonie, Kovianatuk, Tudlik, Noogooshoweetok, Patchow. They were hungry because they thought hunting too much work and gave up looking for food too easily.

Tudlik was never much of a hunter — he used to try to get by just eating seaweed. His son Latchowlassie — that's a different story.

On our way back we never saw caribou but we found five wolves and my brother killed three of them — they were young ones.

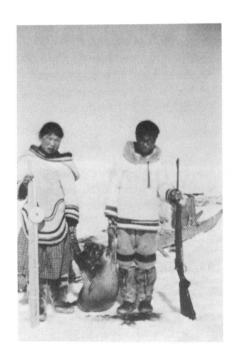

When we got to our boat, it had been turned up. When we had left it we had turned it upside down. It had been painted before we started our long walk and that was one of the reasons we had turned it over. There was only my mother, Pootoogook and his wife and me, and we were wondering how we would ever turn the boat by ourselves. On the long walks we had talked about how we could turn the boat over. There were only four adults and some children and we did not look forward to turning the boat as it would be very heavy. When we saw that it was already turned we were very happy. My brother Eetoolook and his companions had turned it for us. We had left some tobacco and tea in the boat, and with pleasure we then had the kadluna's luxuries.

The next day we hauled the boat into the water and were on our way once again.

We sighted the Keegomuit. There were many tents. Many people came out to greet us. They were all coughing so badly. They had bad colds. The reason everyone had a cold, we found out later, was that there had been a new house built at Kamadjuak for Noovoosiak, the Bay manager. People had gone there to pick up supplies and had brought back colds.

It was 1921. Noovoosiak had a new house at Kamadjuak and Etungat Eshoohagituk was born. Now Etungat Eshoohagituk is 51 years old as I am telling this story in 1972. He is six months younger than Oshoweetok.

We spent the winter near Markham Bay at Eteenik, the 'short cut' — it was used as a short cut by the dog teams. When we were still living in our tents, Matchowjak died and we were very sad. He was on a trip by dog team when he fell in the water and drowned.

He fell in where there was no ice. We were so sad; he was just learning to become a hunter. His poor mother, Peeshootee, was left alone. She became such an orphan.

I am going to write down how many there were of us altogether that time in 1921 when we spent the winter in Eteenik: we were happily 85. That was the number that had breath. Now there are only Oo, Mosessee, Owpalutak, Teemeelak, Ekidluak, the two Pudlats, Takulik and myself, Peter Pitseolak. There are ten of us who remained breathing to reach the year 1972.

That was the time when the Laplanders who worked with the reindeer went to Kamadjuak. (They were called Noovookeeolak because their hats had four points and their boots also had points.) Also, that was when the Americans were at Ejureetuk — that was the time the lovely ship was frozen in the ice. And that was when John Livingston — we called him Pootoogooeetuk, the 'toeless one,' because he lost a toe from freezing — became the boss at Cape Dorset. His interpreter was Oonak, half Eskimo, half white.

We heard that the guides for the American people while they spent the winter in Ejureetuk — they called it Schooner Harbour — were Kavavow, Napatchie and Ottochie. We heard it when it was 1922 and one big American and Pootoogooeetuk, the boss from Cape Dorset, and Oonak and Turstayak went to Kamadjuak from Cape Dorset.

That same year, at Schooner Harbour in 1922, when the days were longer, Ottochie Akkiarook, the father of Kavavow and Napatchie, died.

A long time before he had become the stepson of my father's older brother Kavavow. When he was a little boy he went across with his mother, Napatchie, to Quebec, the other side. When he came back he was adult, and he died here in his homeland in 1922.

In Cape Dorset, when those Americans were camped in Schooner Harbour, that was the first time I heard of moving pictures. They had them with them. The Americans were spending the winter in Ejureetuk because their ship was frozen in the ice. It was the first time as well that I saw chewing gum. Also, good smelling tobacco and perfumed powder. It smelled very good, too. Inukjuak, the wife of Oonak, the interpreter, turned out to have gum and good smelling perfume. Everyone envied her. When we left Cape Dorset I was still talking about the Americans and the good-smelling perfume they had.

A year after the Americans were here with their boat they went over to Greenland with their interpreter who came from Labrador. This translator met a man there called Etookooshook and he happened to mention to him that Kavavow had worked for them in the Cape Dorset area. Etookooshook said, "I wonder if that man is related to me? I wonder if Kiakshuk, Kavavow and Inukjuarjuk have any surviving relatives?" Of course, the translator didn't know so he didn't say anything. But when the translator returned again to Baffin Island I spoke to him and he said to me, "Oh, you have so many cousins in Greenland."

This Etookooshook had never seen our people but he had heard so much about us from his father, my father's cousin. He knew us so well without having seen us. Years before Etookooshook's father had made a journey all the way up the coast of Baffin Island, going through all the camps on the coast. This happened way before I was born. He went by dog team, travelling only in winter. Sometimes my father heard from the camps but he didn't know where his cousin had stopped. In 1922 we heard from his son Etookooshook. He got safely to Greenland. It was safe to travel all the way across in winter.

It was a big trip, but the biggest trip I've ever heard of was that trip made by that man, Knud Rasmussen. I've heard that man was able to do anything.

When we went through Kamadjuak, for the first time, we met the Noovook-eeolak – the Laplanders. We had passed by them when we went to Cape Dorset but we did not meet them until we returned. When we entered their homes – their tents were made from blankets – I smelled birds' nests. It turned out that I had smelled their footwear – they had grass for socks. All they had for socks was grass!

They were very generous with their food. I was very full. All they had for coffee was beans. We had so many beans that we were passing wind all day! All they had for coffee was beans. They would pound the beans first and then make the coffee.

The Laplanders were watching and taking care of the reindeer. These animals, which were just a little bit different from the caribou we have here, came on the "Nascopie." Maybe the government sent them. The Laplanders took really good care of them and they lived through the first winter and the second. (Quite a few reindeer were taken by the wolves. Once the chief of the Laplanders took out his cane to beat off a wolf. He succeeded but though the man killed the wolf, the reindeer died. That wolf had been using

Young girls.

his teeth.) When a reindeer wandered off, the Laplanders would go after it. Their dogs were trained to look after the reindeer. Eskimo people got some of these dogs.

At that time they were trying to increase the caribou here so they got the tuktu and the reindeer together. The animals seemed kind of embarrassed by the people watching as they were getting together. They were looking at the people and were really embarrassed.

Some of the reindeer were killed to be eaten. The meat doesn't have as much flavour as the caribou we have here — it's a little bit watery. Our caribou is absolutely very much better.

One of the Laplanders used to do translating — he was learning to speak Eskimo. I was really surprised when that man said to me in Eskimo that the caribou were eating the willow shrubs. I thought he wouldn't be able to speak Eskimo so soon. We were really friendly with those people. We liked to be with them.

When the Laplanders left and the Inuit took over, the reindeer started dying. They had very stupid people in charge of the reindeer. Cleverer people would be very good at it. They had two good men, Kowmanik and Kakajuke, at the beginning but Kakajuke, the chief, left because he had a terrible ill- ness. Then Kowmanik said he didn't want to be chief; he was getting old and if the Inuit didn't listen to him he didn't want to have to tell them what to do. Those who took over didn't take good care of the reindeer — one of them was the laziest person. They took the reindeer for long walks and left them hungry for a long time. Eventually they started dying.

I think today if Eskimos were to be in charge of the reindeer they would really like it. They are after the money today, and the people in charge of the reindeer had enough money.

When it was 1922, we went to work. Noovoosiak at the Bay told my brothers Pootoogook and Eetoolook and me to go to work.

There were my two brothers, Pootoogook and Eetoolook, myself, Kowmanik, Atchiak and Kovianatuk. All of us were working. Avaleesa worked with us but he went away to Kamadjuak.

We were working on the gravel outside the houses which were being built. We also built houses; we worked hard. And we worked on the Bay skins.

Mosessee, the daughter of Epervik,
Aggeok's brother. She died about 1946,
aged 18, of a throat infection just a
few months after this picture was taken.

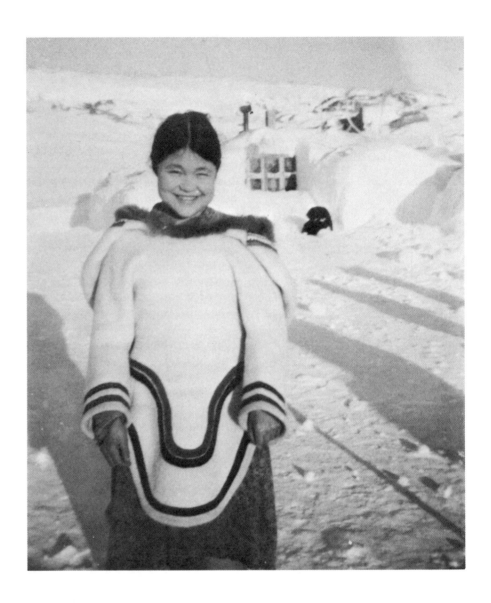

That was the first time I really worked for the white man. Other times, I'd just helped out.

When spring came, we went to Lake Harbour by boat. There were my two brothers, myself and Kowmanik. My two brothers brought their wives.

We were forced to delay at Aulassivik — there was too much ice. Before it had all gone, the "Nascopie" arrived and tried to enter the Lake Harbour inlet but had to give up. No wonder, there was so much ice. The "Nascopie" people were scared that the bottom of the ship might touch rocks below the water. When the "Nascopie" had to turn back because of the ice, it then proceeded quite steadily toward the great winter camp, Okialirialuk. At this camp the "Nascopie" unloaded the goods for the Lake Harbour store. Then, when the ice was gone, the goods were taken to Lake Harbour.

At Lake Harbour at that time, Sowmik, the 'left-handed one,' was boss. His clerk was a white man, Leo Manning, called Ejeekie — the 'small-eyed one.' Also there were the two ministers, Rev. Blevin Atkinson, called Eegatuk — the 'one with glasses' — and Reverend Lackie. Those were the ministers, Eegatuk and Reverend Lackie.

That was the time that I picked Annie for my wife.

The minister Lackie very much wanted me to get married and I very much wanted to myself so I was grateful to this man who told me I ought to get married. He was a fairly good friend of mine, that minister. But he said to me, "Pitseolak, get married to Pitseolak." He wanted me to get married with another Pitseolak. This Pitseolak now lives in Frobisher Bay — she works in a hospital. I said, "Both names would be the same." He told me, "White people get married to people with the same name."

But I didn't want to get married to someone whose name was the same as mine. So the minister asked, "Who would you like to marry?" I picked Annie.

I saw Annie once when she was a baby and I met her again as a young man. My brother Pootoogook, the grandfather of Udjualuk who is translating today, used to say, "Pitseolak, get married to Annie. She's a hard worker and she's a good woman."

So I picked her to be my wife.

Mary Ezekiel, wife of Aggeok's son
Ashevak, fishing through the ice.

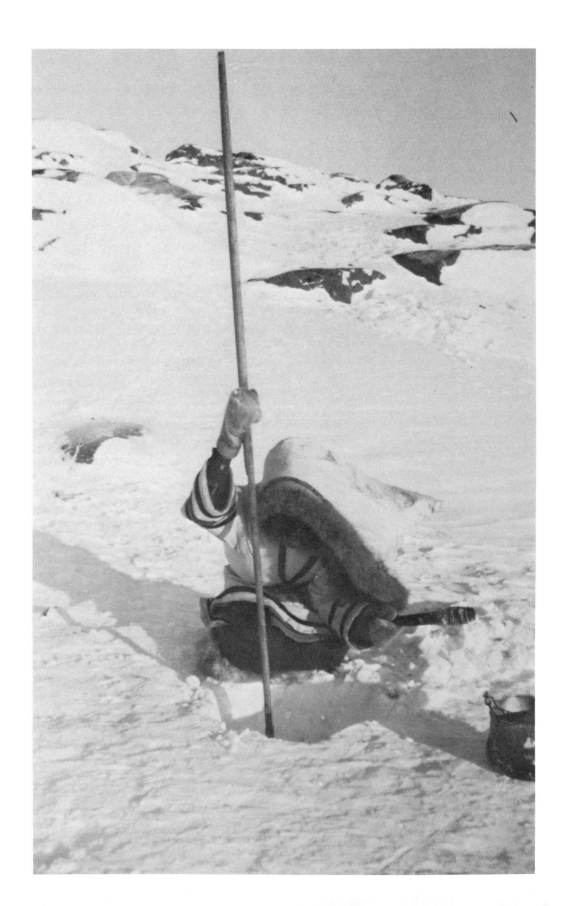

These pictures of Mary Ezekiel were taken during a fishing trip about 1958 when she had her son Palaya up on the back.

That year my family and others went for the winter to Egalalik. We were there for the winter when the year was 1922. That winter there was plenty of fox. The people were living well. No one was poor; we could afford luxuries from the white man — tea, tobacco, cloth.

When we had almost run through the January days, and it was 1923, I went with Pootoogooeetuk, the boss in Cape Dorset, and Tapanni to Lake Harbour. Noovoosiak, the boss in Kamadjuak, and my brother Eetoolook and Kovianatuk were on their way to Cape Dorset and went past us. We saw them but we did not meet.

Later we were to hear that Noovoosiak had a new son. His name was Kitchoalik. He had been born in the summer of 1922. Kitchoalik, the son of Noovoosiak, is a little younger than Agiak Petalosie. They are brothers; their mother was Moatami. It's a long time ago now that Kitchoalik was born. He is 49 years old. He will be 50 when summer comes. We heard that Kitchoalik was born only when my brother told us.

Noovoosiak, the Bay manager, had a new son but Noovoosiak did not tell us about his son being born.

Kitchoalik is a minister now in the North.

When we got to Lake Harbour, I got a wife. Annie, my first wife, and I were married in church on July 15, 1923.

We spent the winter in Ataneekirut at Taseojakudluk camp. Our boss in Lake Harbour was an Englishman. L. A. Learmonth was his name. In Eskimo he was called Weetagalik — 'wide-open eyes.' His interpreter was Joe Palliser; in Eskimo he was called Omeekutak — 'long beard.' The boss's clerk was Keenakie — 'small face.'

In 1924, for the first time in my life, I was really scared. My father-in-law, Attachie, had lent me his gun. When I tripped carrying the gun, it broke in half. The wood part split. I had not even used it. I was afraid of my father-in-law!

My first daughter was born when we were spending the winter at Okialirialuk. When we were about to spend another winter around Lake Harbour, my mother, Kooyoo, arrived. While we were inland during the long summer caribou hunt, Kooyoo got on the Bay ship and came from Cape Dorset to Lake Harbour. She had missed and longed for me.

Annie's grave above Cape Dorset. She died in 1941.

After we had spent the winter at Okialirialuk, when it was almost spring, my brother came after us. When my brother Pootoogook came for us we were camping at Aulassivik — the old caribou taming grounds. That was when it was 1925.

We spent the spring at Ekataleeroolook near Eteenik.

I am going to tell another story. When it was almost autumn we were left alone at Kamadjuak. There was my wife, Annie, my baby daughter, my mother and myself. Our companions had gone to look for boats.

It was 1925 and in 1925 came the biggest scare and fright of my life. That had been a big scare, I thought, when I broke my father-in-law's rifle in 1924. But it turned out that the biggest fright would come in 1925. In all my life, this was the time I was most afraid.

It was the time that Johnny, the white interpreter, died.

I was afraid because I thought that people would blame me; I was the one who might have saved him. I was out in the kayak hunting. Johnny, Simeonie, Moonee, they were in a canoe-boat going to see the seal nets. They were not with us in our camp; they were living and working with the white men.

I know one can panic on the water and they panicked. That was the reason one of them was lost.

Johnny had stepped on the edge of the canoe. It had a sail and he wanted to take the sail down. The canoe didn't completely turn over — if it had turned immediately they could have held on and been saved. The canoe turned half way; it shipped water and went down.

Moonee and Johnny began to cling to each other, grabbing each other to try to keep afloat; they panicked. Johnny had a winter hat that was reversible. When Johnny was panicking this winter hat slipped over his head. When it got wet it would not come off — it was too heavy. He couldn't see. If he had been able to keep his head above water, he might not have died. But he could no longer see because his hat was over his eyes. He was blind-folded with his own hat. He drowned.

I was very afraid. This was the time I was most frightened in all my life. I was the only one who could have saved him. It is a long time ago now but

then it seemed time would never pass. No one blamed me or scolded me; it was only I who felt afraid and sorry for what had happened. I thought that I should have been able to save him. But one can panic on the water so easily and Moonee and Johnny panicked.

Moonee and Johnny grabbed each other in the hope of keeping afloat. They were wrestling in the water and Johnny went under Moonee. He could not see for his hat was over his eyes and head.

I was in the kayak and Simeonie grabbed the back of it and I pulled him to the shore. Then I took Moonee. They were not far from shore.

I put Simeonie* on the land first. I told Johnny not to panic but Johnny got trapped in the ropes. He did not hear me.

When I had brought them all to shore a boat arrived. It was from Eteenik and had been to pick up supplies from Cape Dorset. My mother went to the boat to tell them what had happened. Kovianatuk and his wife were in the boat. As soon as my mother told them there had been a death, Kovianatuk was yelling. Kovianatuk told everybody too abruptly that Johnny was dead. Simeonie was his adopted son. It was not a very good feeling for me when he said, "My son lived but Johnny died." One can panic easily when one does not know the circumstances and he was panicking.

The Eteenik people took Johnny and ourselves back to Eteenik. It was a good thing they had passed by our camp. When we reached Kamadjuak the people there also panicked. The canoe boat was being towed by the large boat, the one used for hunting.

The boss could not speak Eskimo properly; he could only ask, "Where is Johnny?" As soon as he asked, "Nowtima Johnny?" Kovianatuk replied right away that Johnny had died. I thought it was a very poor way to do it. Then Satie said, "Here is Pitseolak. He knows more of what happened."

The interpreter was Eelooweetuk. He could not translate everything and I felt sorry for him. But he could understand and talk English a little and for this I was thankful.

*Simeonie is alive today and living in Cape Dorset. He is a catechist in the church and played the role of the camp chief in the Paramount movie, "The White Dawn."

When it was late autumn a boat arrived at our camp. The people were on their way to find skins for trading and we went along with them. We should never have gone with them! If we had stayed put we would not have gone hungry. But hungry we were. We looked for walrus; only two walrus were killed.

Later we went to celebrate Christmas and we did not return to our winter camp where we had felt hunger.

When it was 1926 we were living at Ooleemavik near Markham Bay. We were fortunate to have enough food there. We had caribou and seal. There were only my brother Pootoogook, his family and my family. We were the only people sharing the land. Then some more people moved to our camp; they were in need of food. Since we had food they moved to us. As usual, the people from Akudnik – the camps between the Lake Harbour and Cape Dorset areas – were hungry. They were always going hungry because the hunting wasn't good. They always had to go and get supplies from Kamadjuak.

People in Seekooseelak always thought they were a bit smarter than the people in Frobisher and Lake Harbour. They'd hunt and cache the meat. But the people in Lake Harbour only wanted fresh meat and they thought they could hunt and get it whenever they wanted. They'd say, "Oh, those people from Seekooseelak, they eat rotten meat." Once I was translating for a policeman who was giving out bullets in Lake Harbour and he said, "Tell the people they should be more like the people in Seekooseelak; they should put aside meat for the time when they are not able to hunt seal and go trapping for fox." I didn't want to say this because I was from Seekooseelak but the policeman said, "It is I who say it, not you."

There is a word for the season of starvation: 'akunakhee' – in between. It was the season between winter and summer when it was hard to hunt. Then the snow on the land is soft and the sleds stick. It was not much use going after the animals – you couldn't catch them. On the ice you could sink and if you used the kayak on the open water sharp ice pieces could dig in and make holes. Then the currents in the water are strong and at this time the young seals can run away quickly. We would go after the seaweeds and dulse and eat them with the aged-blubber dip. It was nutritious – we weren't weak – but you couldn't eat too much of it; you'd get a stomach ache, a bad case of indigestion.

When the men wanted to go hunting very badly they would throw into the ice a naked baby bird or a baby lemming that still had no fur and hope for the north wind to scare away the ice. This was the old, old custom. It worked –

sometimes. When there was a lot of ice in the bay the men would tell their children, ''Go get a baby lemming – or a baby bird.''

When I was growing up I also heard that when the weather was very, very bad in the summertime and the waters were rough for many days, the men would go looking for a raven. They would hope for a raven that was very, very fat . . . a raven with a lot of fat in the stomach. That was the best. They took the fat and pounded it with a rock. Then they threw the fat into the sea and hoped for calm waters. Sometimes it worked; sometimes it didn't. I tried it and all I got was oil on the water. But people around Seekooseelak didn't go hungry that much in winter. They were able to use their kayaks because in Seekooseelak there were hardly any ice floes. And hungry people would watch the floes to see if there were black marks running down. If there were, there had been a walrus killing so they'd look for the people who had the meat. It was good meat and there was more of it than of other kinds.

In my life I have never come across a real starvation – I know of only two people who died from starvation. But there's a place over the hill from Frobisher Bay where before I was born people died from hunger after eating each other. They started from Markham Bay but they ran into spring. They were travelling by dog team when the snow melted and they had to walk across. Just recently somebody found an old kayak that had belonged to them at the place where they died. They starved around Frobisher Bay. I don't know how many there were but I've heard they were many.

Sometimes starving people kill a person to eat. When they had to do this they always picked a boss. The boss selected was not necessarily the smartest person but he'd be a boss of the killings. He'd tell them who to kill. It didn't matter who you were when the man in charge of the killings said, ''I want that person.'' He had to be fat – to be a good candidate to be eaten. The boss would tell the people to kill whoever he thought would be the best to eat.

These people killed their camp boss first. They came to life for a while on him. Then they started to starve again.

Two women were the only survivors; they did not kill each other – maybe because they were not bosses. They started to walk when there was no one left to eat. One of them had a little girl – she was not a baby but they carried her to keep her warm. As they walked they gave her some of the human meat so she would not starve. They walked down to the bay and there people found them. They weren't moving at all. They couldn't go on. They were just sitting there on the tails of their 'amoutik' – their parkas.

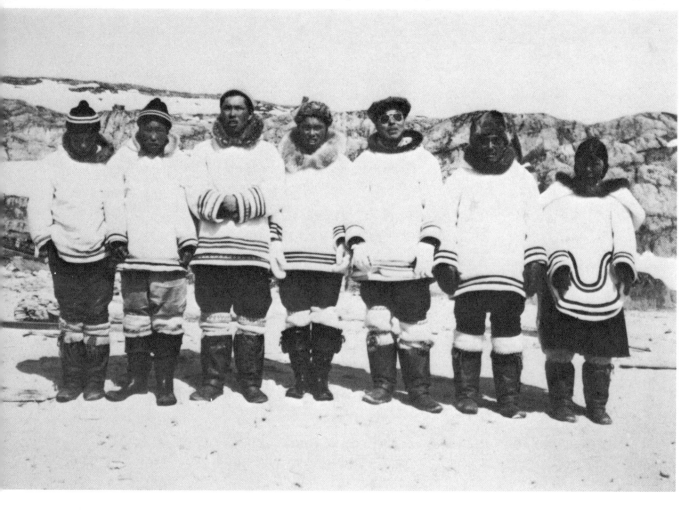

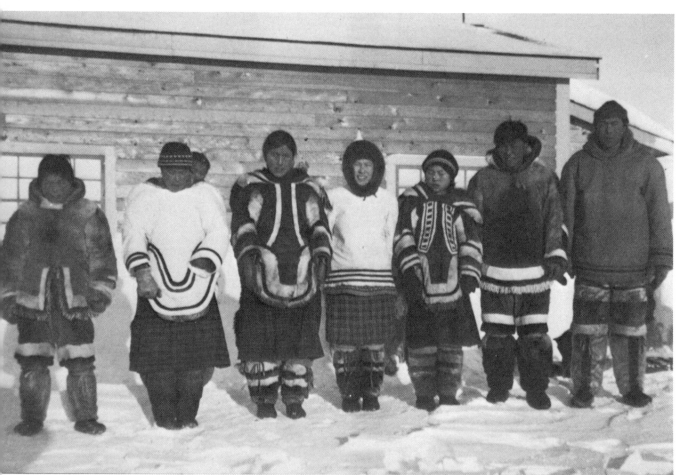

Pootoogook, last boss in the Seekoo-
seelak area, and his family. Left to right:
Kananginak, Eegevudluk, Paulassie,
Pudlat, Salamonie, Pootoogook and his
wife, Ningeookaluk.

Outside the BTC in Cape Dorset.
Left to right: Kowmadjuk, son of Kava-
vow, Peter Pitseolak's half brother, his
mother, Quatsia, Aggeok, Udluriak, Kooyoo,
her husband, Kovianaktilliak Ottochie,
Johnniebo.

*When people found them their faces were so skinny they looked as if they
were smiling.*

*Inuit people say if a person has eaten a human being his mouth is always
dark. I have often asked Aggeok, who knew the baby who was carried and
survived, "Was her mouth dark?" Aggeok always says, "I am sure it was
dark."*

*Issacie in Frobisher knows more about this story but he never talks about it.
People don't like to remember these things.*

*They were not the only people to eat human beings.**

When spring came we went to Cape Dorset by dog team. Then we spent the
spring camping at Taseejuakjuak. Then we went to wait for the coming of
the "Nascopie."

When the "Nascopie" came, both my brothers and I went with her to
Kowshoweetuk, the high Arctic. It was 1926 and we spent the winter at
Toojarooolook — Fort Leopold on Somerset Island.

*It is dark up there in the wintertime. No sun at all. The people are different,
too — they talk with their hands like French people do.*

Our white bosses at this time were Ralph Jardine — those people from the
high Arctic called him Makootoorooluk, meaning 'young man,' and Neekusi
— John Nicol.

There were also six white men from Labrador who, a long time before, had
been Eskimo.

*A long time ago there was a battle between Eskimos and Indians. The
Eskimos didn't have enough weapons — they were in kayaks — and the
Indians had more power; they won. When the men were dead the Eskimo
wives lived with the white people. They had children. That's how it hap-
pened. I heard it from these people. They were medium people — not really*

*A notable instance occurred among the 129 men of the last Franklin expedition which set
out in 1845 to search for the Northwest Passage and came to a disastrous end. ". . . it
is evident that our wretched countrymen had been driven to the last resource . . . ,"
wrote Dr. John Rae of the Hudson's Bay Company in 1854 in his report to the Secretary
of the British Admiralty.

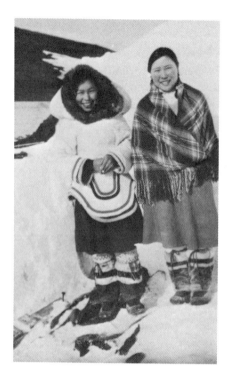

Eskimo, not really white. One of them had a skin blacker than mine but none of them could speak a word of Eskimo — not a word.

I learned some English from these people but they spoke like Newfoundlanders. They spoke in an unusual way — different from other English people.

I was working for them; Pootoogook was working for the store and my brother Eetoolook was my helper. Also with us were Manik and Makie who were from the high Arctic. That year, in 1927, there were many foxes in Fort Leopold. We were able to buy anything we needed.

Then the RCMP ship arrived and we got on the ship. The Hudson's Bay Company ship had been lost and, as no other Bay ship could come to the high Arctic to bring us supplies, we were told to get on the ship and return.

We spent only one night in Lake Harbour. We were on land for a very short time; we spent just one night in our tent. My brother Eetoolook and I had been told we were going to Toojak — Nottingham Island. We were told we were going to work. We had been chosen because we understood a little English. The police ship took us to Kagishoojuak — Wakeham Bay — and we were at Wakeham Bay for one month.

There in Wakeham Bay when it was 1927 was the first time I saw a flying machine* in the air. When it was flying I thought it was doing incredible things. The next time the flying machine was to go up, Pingwartok was taken along. He was only a little boy then. It was said that he was the first Eskimo to ride in a flying machine.

We were finally taken to Toojak by the government icebreaker, "C.G.S. Stanley." This was a beautiful ship. I have never seen another ship like this one. It had so many lights — it had more bright lights than any other I have seen. This ship with all the bright lights brought us to Toojak. It had on board 12 white men.

It was 1928 when, for the first time, I rode in a flying machine. They had two of them at Toojak.

When the weather was nice they were flying around all day looking at the ice. When it was cloudy, they were scared to go up. They were fixing the

*These were Fokker aircraft with the 1927-28 Hudson Strait Expedition. The RCAF established bases at Port Burwell, Nottingham Island and Wakeham Bay in order to survey ice conditions in the Hudson Strait.

port at Churchill, making it deeper for the ships. The planes would let the ships know when it was safe to go ahead.

Eetoolook was working for the flyers. He had the job to go up every day and to help them if they crashed. He was brave on rough water, too. They said if there was a crash that white people wouldn't know whether they were on the ice floe or land. One plane crashed near Fort Burwell and, if they hadn't had Eskimos there, they would have been lost.

Both Eetoolook and I had been tested for the job. I was so frightened my intestines were in my mouth. The plane swooped straight up in the air and down again. I was scared. But it didn't bother Eetoolook. He got the job. Even the pilot got sick before Eetoolook.

Eetoolook could do many things. He was always used by the kadluna. He had a Peterhead. He was the first to have a real house in camp. He had good dogs — ten of them. His dogs were beautiful. He had two real wives he married in church. He divorced the second and married a third. And there were some others. His first child was turned down. I guess they thought Eetoolook wouldn't look after it. The first real wife had seven children, the second had two, and the third had one child. Davidee, the Lake Harbour carver, is his son. Eetoolook became richer than I; and richer than Pootoo-gook, too.

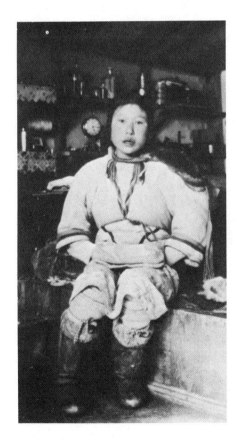

He died in 1946.

The year 1928 was not a very happy time; my mother died. It was almost spring, the days were longer, when we lost our mother. I have always been grateful to the people from the other side; they helped us bury my mother. Those who helped are no longer living, but one, Meetiajuk, was especially kind and I was very thankful. She nursed and looked after my mother when she became sick.

It is 44 years since my mother died. Now it is 1972; my mother died in 1928. I have been without her now for a long time.

When winter came we were still at Toojak and my wife and I had a house made of the lumber that had been used to pack a plane's wing. It was cold for it didn't have a lining. We had all the wood and coal we could use — there was plenty — but it was cold because it didn't have two layers. No wonder it was cold. I had to build an igloo instead; the house became the hen house.

The white men had cows and chickens with them. The cow makes the best broth — when the bones are in it.

123

Kooyoo (left) and Udluriak. The bead-
work in both pictures is the same and
was made by their mother Annie for
Udluriak. Beads probably came with the
whalers. Aggeok has known them all
her life.

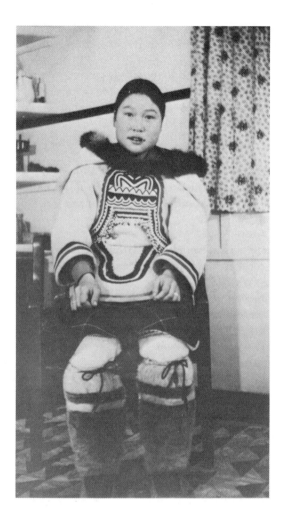

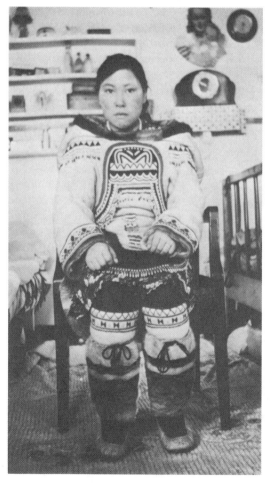

Bosses are never alike. When it was 1929 our boss in Toojak thought he was the boss to end all bosses. Because of this I was once again on my own. I would go to work if there was much work to be done, but our boss thought he was the only man with a mind. I was not scared of him but he was scolding too much. I did not want to do bad things; I went off to camp. I did not want to have bad things to think about. Working for him was not the only way to make a living; he was the boss but he was bossing just too much.

When summer arrived my brother Pootoogook came and I was happy to go back to Cape Dorset with him. The boss at Cape Dorset, Owpatuapik — the 'red-faced one' — was good. His English name was Chesley Russell. His interpreter was Henry Voisey.

I have been around Cape Dorset ever since that time.

In 1930 there were many fox. Our camp was Ikirassak and it was a very happy time. Our boss was happy and he was a good boss. And in the second winter at Ikirassak my daughter Rebecca Kooyoo was born.

I am stopping for now. I have been telling a story too long.

Building new houses, probably in
Frobisher Bay.

Modern times

Peter Pitseolak's house at Keatuk, probably taken in 1947 shortly after the house was built from lumber salvaged from the "Nascopie." In the winter picture the house has an igloo porch and is banked with snow for insulation.

Posts and wires are antennae for radio. Programs came from Winnipeg; some people thought Peter Pitseolak had become a shaman – he could predict the weather. At far right is a snow-banked quarmak.

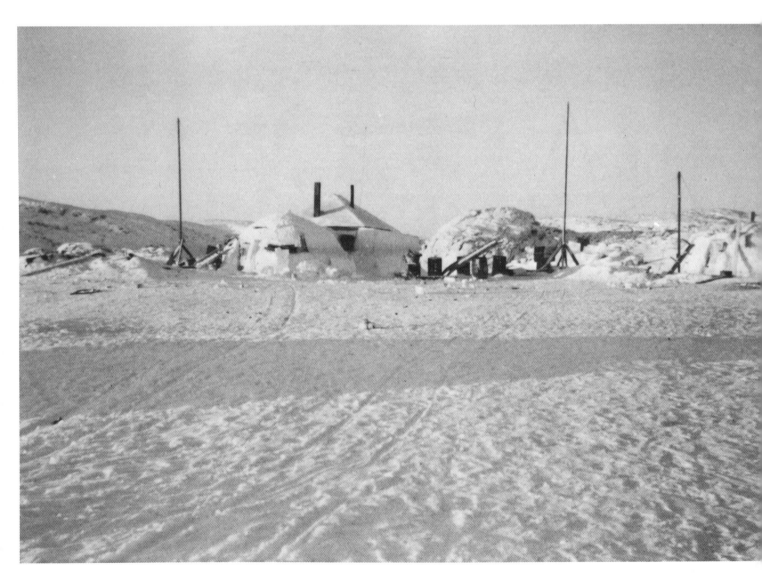

Samuellie Toon and Peter Aningmiuq
visiting Keatuk just after completion of
the house.

My father and mother were always talking about Ohotok, the shaman. Long before I was born, when my father was still a young man, Ohotok had sung about a lovely red cloth flying in the wind in Kingnait — Cape Dorset. And he sang about a wolf, one of the spirits he had. He called his spirit, Eetoongut — 'my old one' — and he sang that Eetoongut was puffing on a pipe and smoke was streaming out of his mouth. This meant there would be tobacco and white men in Cape Dorset.

My father knew Ohotok. He called him the short Ohotok; he was Oshoweetok's ancestor. Both from my mother and father and also from other people I heard about the prediction of Ohotok:

Giant Kingnait,
On its big hill . . .
In between
There is a lovely red cloth.
It is cracking.
It is flapping.
There it is.

Eetoongut —
There he is.
Coming towards . . .
He is smoking.

Ohotok strongly believed in what he had seen and he told the people. Eetoongut, the wolf spirit, had wanted the people to find out there would be white people coming into Cape Dorset. Because he could not tell the ordinary people he chose his master, Ohotok, to be the first to know. The wolf was the messenger to the people.

After Ohotok saw the red cloth flying and Eetoongut smoking, he sent people to Cape Dorset to see if there were white men there. But, of course, there was no one there then.

When I was in hospital in Winnipeg in the south I heard people say that many more white men would come to this land. They said, "The Eskimo will be changed; he will talk like a white man in years to come." I've always expected this and now it's happening. I'm not surprised.

Change came with the whalers. They were the first to start change. The whalers and the people who were after the shiny rocks — the mica.

Kooyoo, breast-feeding Mary, and her
husband Kovianaktilliak Ottochie. About
1950.

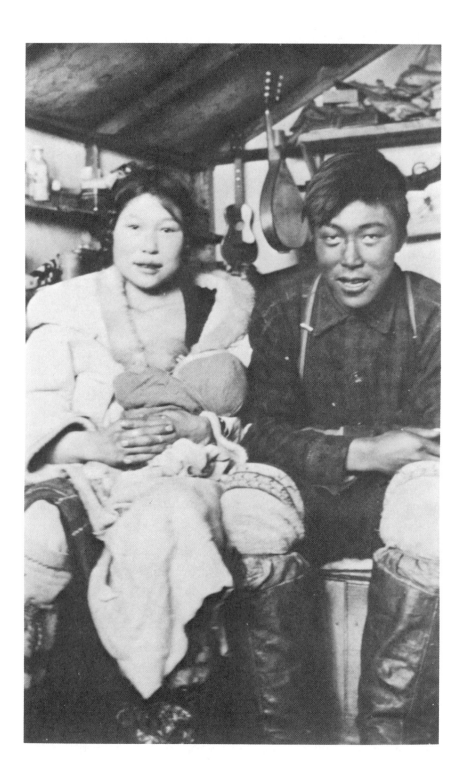

Aggeok in the quarmak. For two years after he built it, Pitseolak and his family lived in the house. When coal salvaged from the ''Nascopie'' ran out, they moved back to the quarmak for the winters.

They were also people who thought the Eskimo people were not very smart.

The reason why Eskimo people look white today is because the women got pregnant from the whalers. It was always funny when Aggeok's grandmother used to tell stories about the captains. ''All the captains wanted me. I've got worse but I really used to be the best-looking woman!'' When I tell this story to people Aggeok always says, ''Why do you recite such a thing? You know the only reason the whalers admired her was because she was available to them!''

The first white people who came were the blue whale hunters long ago. Before there were white people living in Lake Harbour the Eskimo people used to go down to Keetajuak – Big Island – to wait for the ships. The ships that came to Keetajuak were sailing ships without any motors. They used to pass Keetajuak on their way to Cape Dorset and the people went there to wait because they wanted ammunition and food – whatever the ships could give them. They traded with skins. The people started to work for the whalers. I am called Pitseolak after the first interpreter. When Pitseolak was a boy he was picked up at Keetajuak and was the only one to be on a ship with white people. The reason why Pitseolak as a boy was always on the ship was because they were teaching him English so he could interpret. He was born here in Seekooseelak but his family moved to the Lake Harbour area.

Around the time I was born – maybe I was born, maybe I wasn't – there were some kadluna at Lake Harbour: whalers and the people who were looking for mica. A ship had arrived in Lake Harbour, and people had asked whether anyone had seen any mica – and where. Pulie was the one who knew where the mica was to be found and he took the ship up to the stone. Pulie was the first Inuk to be a pilot.

They took a lot of mica out for many years.

The Hudson's Bay people were the first people to stay. The Company built in Lake Harbour in 1911 and in Cape Dorset in 1913. It was a big change when people began to work. When the kadluna things came here, that's when people thought they were rich. That's when they changed. When they thought they were rich in the white man's way they started to ignore the riches of Eskimo life. So much was available to them from the white man. Later it turned out we were not as wealthy as we thought.

There was an increase in the white men in the 1930s. It started with the Baffin Trading Company in 1939 and that same summer the Catholic

131

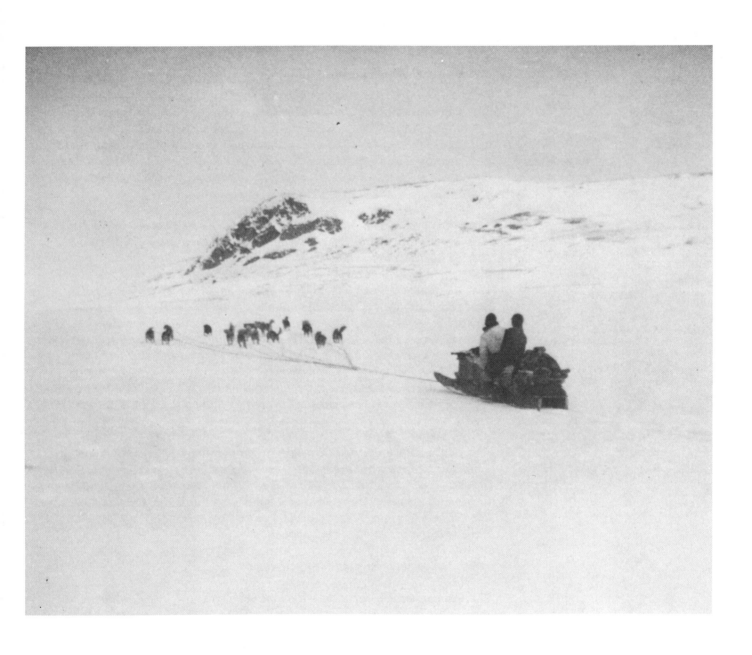

Keatuk people.

Sarah, Mary Ezekiel's sister, and Peter Pitseolak enjoying a tea break while checking fox traps. Peter Pitseolak had two trapping areas and kept twenty dogs, enough for two teams.

Mission came. They built their houses. That was the start of having many white men.

Bishop Fleming used to say, "Don't say BTC – that means bitch! Say Baffin Company." That's when Eskimos were really living, when the BTC was here. Jimmy Cantley was in charge. Once we were walrus hunting for the Bay. I was boss and this Bay man began to scold my men. I said, "Why are you scolding my men? You should be scolding me. I am the one who is looking after them." The Bay manager told them all to get out. So we all got out. I thought I was fired, too. But the boss came and said, "Pitseolak, you must come back. I didn't fire you."

But I told him I had a job with the BTC. They were building their houses then.

While the BTC was here we were well off from the land. They were trading in seal skins and polar bear and walrus hides. The Bay used to take only fox pelts. Once I had a great box filled with pelts. It hardly bought anything; the Bay paid only $5. But after the BTC began to trade in different skins, the Company began to do the same. We felt it when the BTC went away.

It was like a straight pole – well set up – when the BTC was here. When the BTC left I went back to work for the Bay – part-time.

I am going to tell the story of the "Nascopie." The "Nascopie" was the ship that belonged to the Bay, and I'm going to tell how it hit the bottom on July 21, 1947. It was sad; that ship helped the Eskimo people. What it carried helped the people before we had the government. When it sank, we were really sorry.

When the "Nascopie" came there was always a lot to eat. The old cook used to feed the Eskimo people.

When the ship arrived we went on and worked for two or three days. Today everyone seems to hate the ships, but then we loved them. The "Nascopie" used to bring all the supplies for the store; if we hadn't had the "Nascopie" there would have been no supplies. As soon as the ship arrived we ate. We ate outside; there was no other place. Those who couldn't work would cook on the shore. They were also paid. The cook fed us. His name was Storekeeper; they used to call out, "Storekeeper!" Ahalona! He gave everything . . . corn beef, stew . . . everything. That cook loved to feed the Eskimo people.

In 1946 the old cook was replaced by another. The new cook did not feed
the Eskimos. The Eskimo people people felt unwanted. *With the new cook,
the "Nascopie" was changed. There seemed to be nothing to eat on board!
I was the only one who could get food. The new cook invited me – but not
the others.*

The next year there was a new captain also and with the new captain the
ship was lost. The Bay manager had radioed the ship's captain that I should
go down and meet the ship to pilot it into Cape Dorset. The captain said no.
He thought he knew everything. If I had steered the ship, it would never
have gone aground. I had been steering the ship for three or four years. The
new captain did not want me to meet the ship.

Since it was such a nice day I went hunting for seal. I wanted meat! The
captain did not want my help so I went hunting; I got two seals!

On our way home to Cape Dorset we saw the ship looking very high. It
turned out that it had struck the rocks and was on top of them. The tide had
left it behind. When we reached shore, Kululak said, "Our helper has hit the
bottom." So I joked and said, "Then we will take all its possessions." I only
said this as a joke. I didn't know that she had a hole in her bottom. It
turned out that she had a big hole through her. No wonder, as the ship was
very heavy.

That night, when the tides had risen and the ship had let loose its grip on
the rocks, someone sent for me to come and help. Earlier that day my help
had been refused; now, when it was too late, I was wanted.

On our way out to the ship we met a big barge full of kadluna heading for
shore. It was full only of white men and they told us the ship had a big hole.
I was the only person who heard this said – my companions missed it
because of the noise of the motor. I told the kadluna in my boat that there
was a big hole in the "Nascopie." Our boss, the Bay manager, did not want
to go to the ship after I told him about the big hole. So I told him, "We must
go; there are still people there – they are flashing lights because they want
our help." Then we went ahead.

When we got to the ship, our boss said to the captain, "Peter has come to
the "Nascopie" to help." Then I was told to come aboard and told again that
there was a big hole. The crew was trying to get the water out of the ship.
The coal was being thrown away.

When we got aboard the ship, it was raining. The captain said to come with
him. He took us to his cabin. He had the strong water – whisky – all ready

Women of Keatuk.

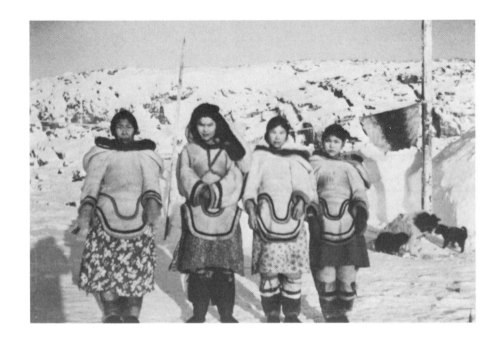

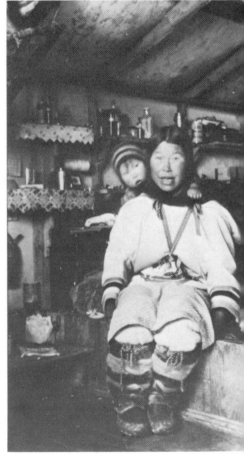

Men visiting Keatuk to help put a boat
in the water.

Peter Pitseolak.

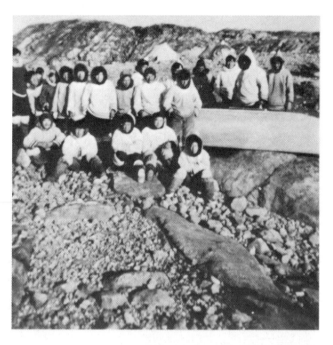

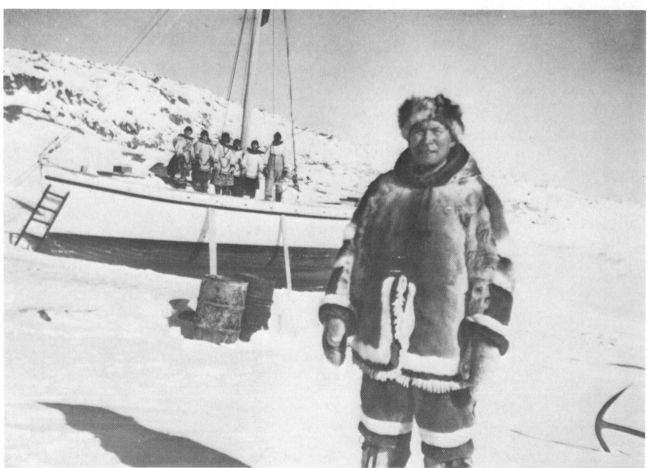

Udluriak. She married Tommy Manning of the Cape Dorset HBC post and died of a heart attack in 1971.

Kudlajuk, Aggeok's mother, in 1948. She is wearing a white fox skin in the white man's way "just for fun."

for us. I did not want to become drunk so whenever the captain turned away from us, I would empty the glass into the pail. (Also, our boss poured out his drink as he didn't want to become drunk either.)

Then the captain told me, "Pitseolak, you are going to run the ship." I replied, "If I am to run the "Nascopie" let us start right now for Cape Dorset." So the anchor was pulled and we started to move. We were moving towards the route when the Captain said, "Let us not go into the deep water too much." It turned out that the ship was slowly sinking. They did not want to let me know we were sinking.

Since I was steering the ship, I turned the ship around. We were then on the right route. The shallows were now behind us and I told the captain that I wanted a full speed. But after I gave the word, we started going backwards! The "Nascopie" was going backwards. Then I said over and over, "What are we doing?" Finally the boss answered, "Ajunamat — it can't be helped!"

We were moving backwards so they could ground the ship. The captain thought we might sink before we reached our land.

It turned out that we were to hit bottom. We were moving backwards towards a little island. We were sinking.

All the ship's boats were put into the water in a great hurry! I was told to get into one of the boats. The "Nascopie" engines were already covered.

I was the only Inuk on the "Nascopie." My cousin Salamonie had come along for his own interest — he had not been asked to come by the kadluna. My cousin and I were the only Eskimos.

The captain was the last to come off the ship. He was told to come. He looked as if he was not getting off the ship into the boat. But our boss told him to come and then he came right away. All the "Nascopie" boats were now on their way to shore. All of them were full of kadluna. More kadluna who had gone off earlier were already on shore.

It was not a happy time. I had been sick in the south. I was not feeling well and I was the only watchman. I had to watch that no one went to the "Nascopie." When the "Nascopie" people were gone, then we were to pick up anything we wanted from the wreck. The kadluna said I was to be the first to take anything I wanted.

At last the ship "Avatuk" arrived — the white people called this ship the "M/V MacLean" — and we took the many kadluna out to the "Avatuk." My

Felix Conrad, post manager for the BTC. He wanted to marry Udluriak but Peter Pitseolak said no. He died in Cape Dorset and his ghost, legend has it, is still there.

Peter Pitseolak wearing parka with BTC badge. Taken by Aggeok about 1943.

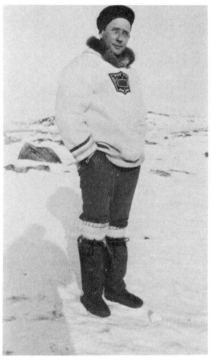

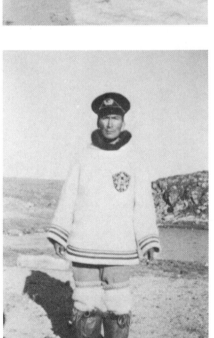

brother Pootoogook's boat also took some kadluna to the ship. Then the kadluna waited until my brother Pootoogook and companions were back on shore and told me, "Go, take as much as your boat will hold."

Soon my boat was full; it was not a small boat.

Then we had company — Simeonie and companions. They were also taking things. It was a happy time — until we reached shore. When we reached shore it turned out that we were to be scolded. My brother Pootoogook was upset because he, too, wanted things from the ship. It was unpleasant. He scolded us for taking things which he wanted himself. But I was the one who was to take what I wanted.

Our boss came to meet us on the shore. When he saw things he especially liked, he told lies. He said, "That's my order."

I was being pretty soft and giving things away. That's why there were many people at the shore meeting us. Then, all of a sudden, I got angry. I told the boss, "These are all yours! Take them all — all the things in the boat!" I told him all this and then he left us alone.

There was also a silly policeman from Lake Harbour. He was also taking what he liked — taking things away from us. It was greedy. I told him he was taking the possessions of the Eskimos and then he slowed down his grabbing. He had been taking away whatever he liked from the Eskimo people.

Then those who wanted to drink got drunk. The police and Bay people had said not to touch the liquor. Eskimo people who were stubborn, they became drunk.

Of all the ships, the "Nascopie" was the most appreciated by the Eskimo people. The "Nascopie's" old cook used to feed the Eskimos, and the "Nascopie" helped the Eskimo people by taking them along where they wanted to go. We were sorry when she sank. She carried many things to buy that were useful and helped us very much. Since the "Nascopie" sank, the ships that come are not so much appreciated. When the "Nascopie" could be seen in the distance, many people were happy.

The "Nascopie" did not wait for the okiak — the 'time when everything is frozen.' By then she was no longer visible in the water.

For a time the people were rich with all the possessions they had from the ship. Today no one has those possessions; worldly goods do not last forever.

Distant dog teams.

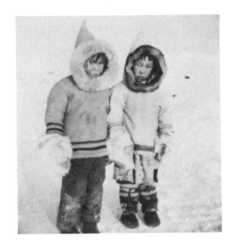

Koperqualook and Pudlo, both teachers today in Cape Dorset school. About 1951.

But even the people from the other side, from Eenookjuak – Port Harrison – came. They, too, came to collect from the ship. There were three boats – Sajueelee's boat, Johnny's boat and Kasaluak's. Also people came from Lake Harbour – Nuvolia's boat and also a short boat that belonged to Kepanik. Their boats were stuffed with things. Maybe the people from Port Harrison did not collect too much but the people from Cape Dorset gave them some of their collections. They couldn't collect themselves from the ship because when they came the "Nascopie" was half sunk.

People in the south heard about us. Our Bay boss wrote a letter which told lies about us. In his letter he said, "They are not hunting for fox any more – they are just sitting down because now they are rich." I did not like this at all. He told lies. We were hunting for fox; what he wrote was not true. He was wrong. Some people do not even try to be truthful.

I know for sure, as I am from Cape Dorset, that we never just sat still. We were hunting for fox. That Bay boss told a lie when he wrote what he did. (I know, so I have included this part in my story.)

The "Nascopie" was the only ship that fed the people. Now different ships come but they don't feed us. There was only one ship where we were fed.

After the "Nascopie" sank, I was asked by government people who came on the ship whether I wanted teachers and nurses in Cape Dorset. They said, "If you want them or don't want them, it's up to you . .·. because you're boss here." I had to say whether or not they should come.*

*The white people said to get two other men for witnesses – they were not to say anything, just to witness. So I picked two men who were considered smart: Pootoogook and Olaegee. They were the witnesses. (Just once at this time my brother Pootoogook and I had an argument. He said, "Why are you boss? I am much older." I said, "Age has nothing to do with it. I was picked to be boss."**)*

*Dr. Andrew Moore, a Winnipeg school inspector, was employed by the Federal government to survey education potential in the eastern Arctic and was on the "Nascopie" at the time of the shipwreck. He was accompanied by Alexander Stevenson now of the Department of Indian and Northern Affairs who is credited with saving the "Nascopie" library of rare arctic books.

**Although Peter Pitseolak was boss at Keatuk, his own camp, in the years that followed this discussion Pootoogook firmly established his power and authority. With his many sons as lieutenants, he made his influence felt as far as Frobisher Bay. He died in 1959 and is remembered in South Baffin Island as the "Eskimo King."

141

Annie, adopted daughter of Peter Pitseo-
lak and Aggeok. The family left Keatuk
and moved into the Cape Dorset settle-
ment when Annie went to school.

Aggeok still has the flag used as a background in this small series of photographs. Top and bottom are Udluriak and Nivee, daughters of Aggeok's brother Towkie. Mark Tapungai is in the centre.

When these important white people wanted to talk we had to move a little bit away from the houses so nobody would hear. I thought these white people felt shy. First they asked me, "Would you mind having a nurse and a teacher here in Cape Dorset?" After this I had to think it out. I did not want to give any rush answers. I knew there was no doubt white people were coming to our land. I had been told when I was in Winnipeg that white people would come more and more to the North. Since I knew the white people were coming anyway, I thought to myself, if there are no teachers in Cape Dorset and there are teachers in other places, then Cape Dorset will be behind.

So I said, "If they want to, let them come." But I knew it would be the beginning of difficult times.

I knew that some would sink down and fall away from their own people. I knew that life would be changed.

I knew that some would learn English but that others would not learn enough; that people who went to school and learned something might think themselves better than those who did not. I also thought that the teachers might not keep everyone in school — some who made trouble would be thrown out. And I thought the kadluna would have rules for the animals which the Eskimos would not obey — maybe some would but others would not.

What I thought in my mind has come true.

Young people who sometimes cannot talk even enough English to be translators speak only in English when there are other Eskimo people around. The people who do not understand English think the young people are talking about them. Today I sat with two boys and they spoke in front of me like this and I thought, "They think I can't do a thing by myself."

With the game laws, they seem to be trying to stop the Eskimo from hunting his own animals. The game laws are all right if they do good. If an Eskimo shoots an animal and leaves it there, that's no good, but it's not wrong for the Inuit to shoot their animals for food.

The teachers came in 1950 and the government came in '56. After this we started coming into the settlement. I left the camp because my grandchildren had to go to school. I was afraid they might try to walk there and on the way they could very easily freeze. And I thought, if a teacher or anybody else gave a child a hard time, he would be unhappy and try to come home.

Jose and Meekitjuk built their house from scrap lumber made available by Americans in Lake Harbour during the war.

After Peter Pitseolak and his family moved to Cape Dorset in 1961 they lived in an 'elovigarguak' — an artificial snow house. In the community at the time there were five plastic igloos — they came in pieces and were assembled — and Aggeok says, "They were warm even in winter." After Kingwatsiak died when one caught fire people considered them unsafe. In foreground are Ottochie, a life-long friend of Peter Pitseolak, and his children Tierak and Pingwartok.

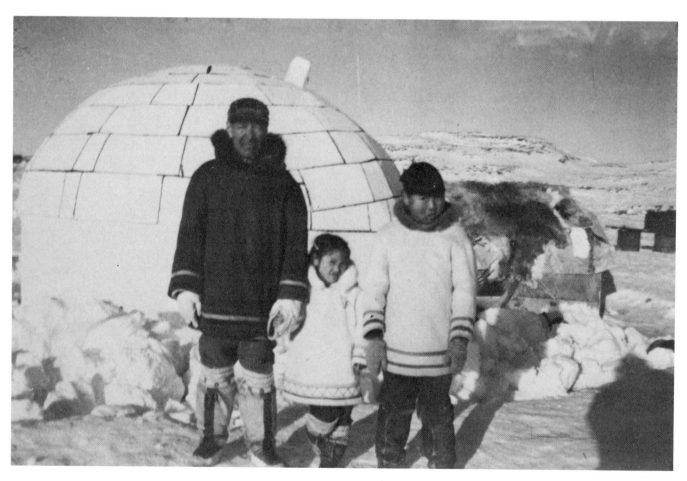

144

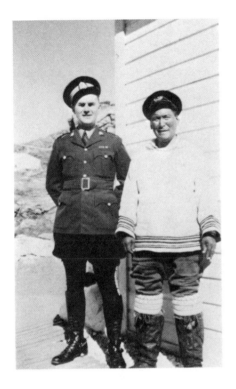

If he made a mistake in the direction he could get lost. I think the other campers thought the same thing. My camp at the time was Keatuk, not far from Cape Dorset. When I was sick in the south with the kidney they had told me it would take two years to heal and that I should not live far from Cape Dorset. I built a house in Keatuk; the others had the 'quarmak' – the tent hut.

When the government came here, James Houston, whom we call Sowmik – the 'left-handed one' – was heading it up.*

It was when I had my fight with Sowmik that I felt I was the worst man in the world, that I was different from other people. Sowmik had asked me to work for him but my muscles used to get sore so I refused. But I first didn't care for Sowmik when he organized the sealskin clothing contest. All my family was in nice sealskin clothing and the others received prizes but my son Mark and I didn't. When I pointed it out I received a small box of food and Mark maybe a little piece of candy. But Sowmik had promised rifles. Then when I wanted to take a second wife, Sowmik said, "Do that and you'll go to jail." I thought, why? Why pick on me? Because the people around me – the white men too – were doing the same thing.

It was bad when Sowmik was telling me off but after I was sent to Lake Harbour I decided I was wrong and that it was wrong for me to get mad at this man Sowmik. I decided to forget about it. I felt better in my mind after this.

Maybe Sowmik did this to me because I had refused to work for him.

After Sowmik came there were many changes. You could very easily notice that people started being their own bosses. They didn't listen any more to what was the right or wrong thing to do. They followed their own ideas.

Today the carvings and the prints are the great helpers.

When Sowmik first came in the early fifties he gave little cheques to people when they brought him carvings. The poor people who weren't able to make

*James Houston, the writer and artist credited with introducing Eskimo art to the south, was first civil administrator for West Baffin Island. In the incident related here, tradition and custom come into sharp conflict with new concepts of marriage and laws concerning age of consent. Until the beginning of the sixties women were taken in marriage in their early teens. Few arctic women regret the passing of this custom.

Seekooseelak children.

out would bring him little carvings. In my camp we weren't poor, and there were not all that many poor people, but there were enough.

When I was a boy the Company used to buy carvings from ivory — not stone. At that time there weren't many people who carved. The manager chose three men to do carving: my brother Petalosie, Issacie, an old man now living in Frobisher — he was a very good carver — and Kenojuak, the grandfather of Kenojuak the print-maker here in Cape Dorset. Those three men. I did a carving for the man once myself but it wasn't very good! It was a white whale but it had a scratch.

Today I prefer the carvings as my eyes are not good but I did my first drawings in 1939 for Johanassie Buchan* in a scrapbook he gave me when he was at the Bay. They were of hunting and people and animals. When I finished one, I turned the page. I did them with pencil first and then I filled in with a brush. I got the paints from Johanassie Buchan. He was a good man for paying.

Today people are happy when they are carving or drawing because they are making money. They pay well for the carvings at the Co-op. Last fall I got $500, the most I ever got, from Terry Ryan** at the Co-op for a carving with Talilayu on one side and a woman and a couple of polar bear heads on the other.

There's big change today. Now there are more white missionaries in the North there are more problems. When the Eskimo people were teaching each other there were fewer troubles. The old Eskimo people were very smart; very intelligent. When there began to be many white missionaries the people went wrong. But the Eskimos are not having more problems because of those white missionaries. Things that never happened before are happening now.

*While his father was Governor General of Canada, the present Lord Tweedsmuir as John Buchan spent 1938-39 with the Hudson's Bay Company in Cape Dorset. In *Hudson's Bay Trader*, he describes Peter Pitseolak as "... the paladin of his race. A skillful trapper and hunter, the best carver of walrus ivory on the coast ... an adept handler of a dog team and a superb sailor." Lord Tweedsmuir introduced Peter Pitseolak to water colours and gave him a paint box and a sketch block. On this and on a second block sent up by Lord Tweedsmuir's mother, Peter Pitseolak painted some of the earliest artwork, and the only water colours, to come out of Cape Dorset. These water colours have been transferred by Lord Tweedsmuir to the Museum of Man, Ottawa.

**Terrence Ryan, since 1960 art director of Cape Dorset's West Baffin Eskimo Co-operative.

Sometimes it looks as if with the drinking and other things the Eskimo people are just trying to make the missionaries mad. But they are not doing it on purpose.

I'm happy about having white man's food when you want it, and I'm happy about having a place to live where the heat is always the same. In the old days you had to make your own hut every fall and you had to gather all the moss for insulation: the heat was never even. It's a steady heat nowadays in the houses the white man supplies.

But it's not happier living in today's world. Today the Eskimos are not so poor, but long ago I never saw grown-ups fighting. They would argue but without getting mad. Now, everywhere, when they get drunk, they fight. The young people think they know a lot but really they do not know enough. The younger they start drinking the smaller brains they have when they grow older.

One of the problems is keeping honest. Years ago, people were so honest that if a man found a cache of meat and was hungry, he would take only a little bit. Then he'd go around the camps and find the owner. He'd say, "I wonder whose was that cache of meat I ate from?" When someone said, "It was mine," he'd say, "I'm sorry; I was hungry." And the owner would say, "That's all right."

People are less honest today.

Just this morning I thought I'd lost a seal which I caught. People often take them today. But I found it this afternoon.

I know people were happier in the old days. But I know for sure they were not happy every day. They would get angry; they would get jealous of someone trying to take their wife. Nobody can be happy every day. I have known this since I was growing up.

I am not tired of living or tired of people.

Not all of our young people will learn the good ways, but the better ones, the ones who care about themselves, will learn the new ways. I have often thought that one day there will be an Eskimo doctor. Not now but in the future. Perhaps one of my grandchildren when he grows up. I think this because my mother was almost a doctor. She was always cleaning the wounds.

For myself, I am sad that the Eskimo way has gone.

Udluriak and companions departing.

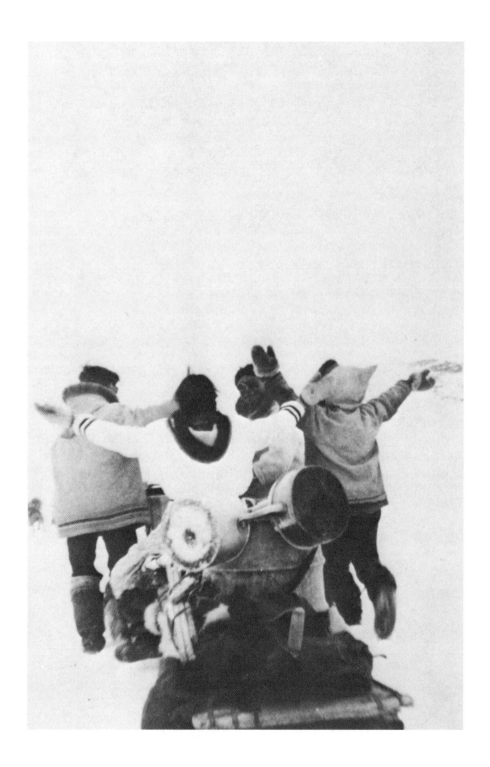

Postscript

Far from the Inuit world and perhaps about the time Peter Pitseolak's grand-father, Etidluie, set out to return to Baffin Island in his sealskin boat, the Scottish writer Thomas Carlyle wrote, ''In books lies the soul of the whole Past Time.'' Peter Pitseolak believed in the power of the written word to preserve and he devoted the last year of his life to leaving this record of a unique lifestyle which he cherished and which people all over the world have admired. He died September 30, 1973, a man who lived to the hilt in the world of his time.

Dorothy Harley Eber

Water colour portrait by Peter Pitseolak of Lord Tweedsmuir beside his sled. Done in 1939, this portrait is one of the earliest Cape Dorset art works of the contemporary period. It was executed after Peter Pitseolak watched Lord Tweedsmuir painting and represents his first attempt in the medium. Tweedsmuir worked for the HBC during his father's term as Canadian Governor General.

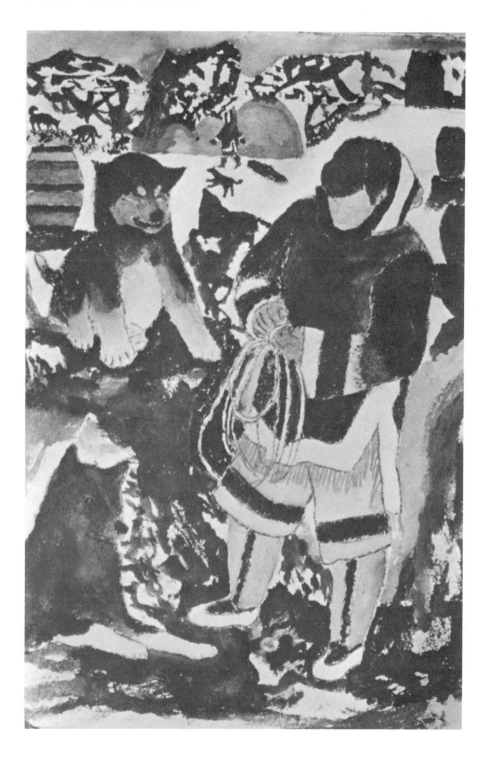

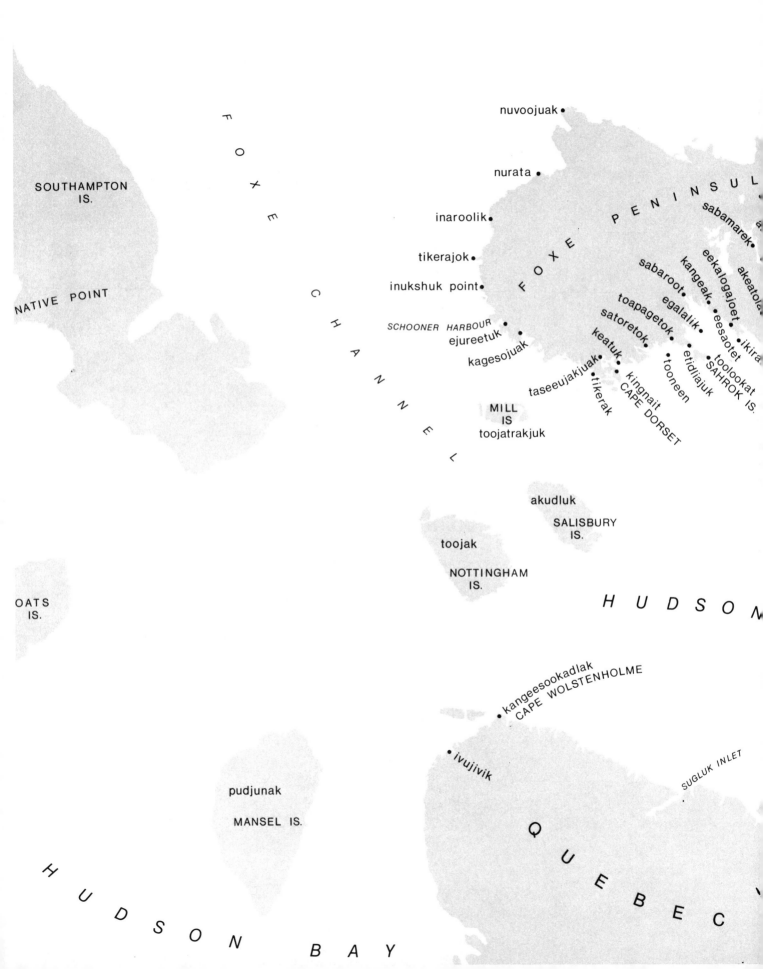

SOUTHAMPTON
IS.

NATIVE POINT

F O X E

F O X E C H A N N E L

nuvoojuak •

nurata •

inaroolik •

tikerajok •

inukshuk point •

F O X E P E N I N S U L

sabamarek •

sabaroot •
kangeak •
eekalogajoet •
akeatola

egalalik •
eesaotet •
ikira

toapagetok •
toolookat
SAHROK IS.

satoretok •
etidliajuk •

SCHOONER HARBOUR
ejureetuk •

kagesojuak •

keatuk •
tooneen •

kingnait
CAPE DORSET

taseeujakjuak •
tikerak •

MILL
IS
toojatrakjuk

akudluk •

SALISBURY
IS.

toojak •

NOTTINGHAM
IS.

H U D S O N

OATS
IS.

kangeesookadlak •
CAPE WOLSTENHOLME

ivujivik •

SUGLUK INLET

pudjunak

MANSEL IS.

Q U E B E C

H U D S O N B A Y

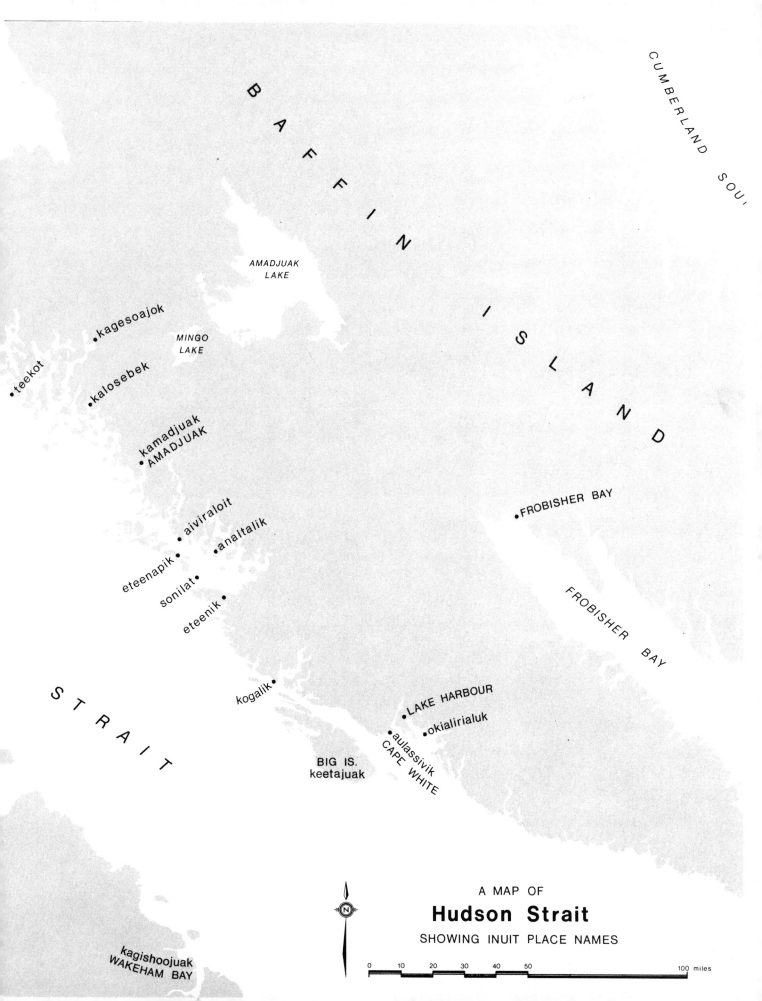

CUMBERLAND SOU

B A F F I N I S L A N D

AMADJUAK
LAKE

• kagesoajok

MINGO
LAKE

• teekot

• kalosebek

kamadjuak
• AMADJUAK

• aiviraloit
eteenapik • • analtalik
sonilat •
• eteenik

• FROBISHER BAY

FROBISHER BAY

kogalik •

• LAKE HARBOUR
• okialirialuk
• aulassivik
CAPE WHITE

BIG IS.
keetajuak

S T R A I T

kagishoojuak
WAKEHAM BAY

A MAP OF
Hudson Strait
SHOWING INUIT PLACE NAMES

0 10 20 30 40 50 100 miles

List of principal characters

Family members:

Peter Pitseolak, the narrator
Etidluie, the grandfather
Atsutoongwa, the first of Etidluie's three wives
Ekahalook, the second wife
Alenga, the third wife
Kiakshuk, the first of Etidluie's three sons
Kavavow, the second son
Inukjuarjuk, the third son and Peter Pitseolak's father
Nirukatsiak, the first of Inukjuarjuk's four wives
Khreemipikulu, the second wife
Kooyoo, the third wife and Peter Pitseolak's mother
Kowmadjuk, the fourth wife
Petalosie, Peter Pitseolak's eldest half brother
Joanasee, a brother
Paulassie, a brother
Pootoogook, a brother
Eetoolook, a brother
Eleeshushee, a half sister
Parr, Eleeshushee's husband
Etidluie, Kavavow's eldest son and Peter Pitseolak's cousin
Mapaluk, Kavavow's second son
Ottochie, Kavavow's adopted son and the father of Pitseolak Ashoona
Annie, Peter Pitseolak's first wife
Aggeok, Peter Pitseolak's second wife
Udluriak, the eldest daughter of Peter Pitseolak and Annie
Kooyoo, the second daughter

List of principal characters — cont'd.

Important personalities:

Kingwatsiak, the source of the story Peter Pitseolak tells about the contact with the last Tooniks
Keegak, the leader of the first religious time
Martha, Keegak's wife
Sila, the first boss in the Cape Dorset area for the HBC
Meagojuk, an Eskimo who survived the wreck of the "Seduisante"
Meesagak, wife-sharing partner of Meagojuk and a ship's officer, who was lost on the "Seduisante"
Alariak, the shaman
Talilayu, the half-whale woman and Eskimo deity
Commock, a hunter who with his family tried to cross the Hudson Strait on the ice floes
Napatchie Ottochie, the brother of Pitseolak Ashoona who fought to keep his wife
Ohotok, the shaman who predicted that white people would come to Cape Dorset

PARTIAL FAMILY TREE SHOWING ANCESTRY OF PETER PITSEOLAK

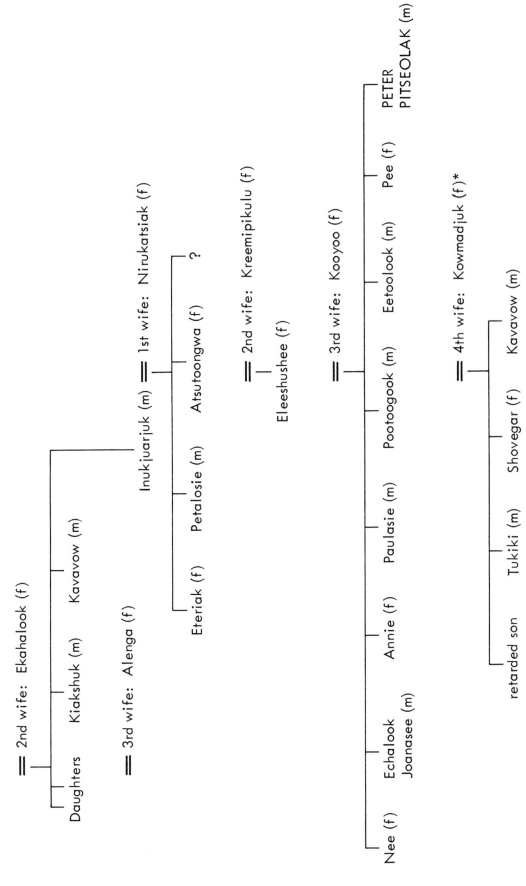

Etidluie (m) ══ 1st wife: Atsutoongwa (f)

══ 2nd wife: Ekahalook (f)

Daughters Kiakshuk (m) Kavavow (m)

══ 3rd wife: Alenga (f)

Inukjuarjuk (m) ══ 1st wife: Nirukatsiak (f)

Eteriak (f) Petalosie (m) Atsutoongwa (f) ?

══ 2nd wife: Kreemipikulu (f)

Eleeshushee (f)

══ 3rd wife: Kooyoo (f)

Nee (f) Echalook Annie (f) Paulasie (m) Pootoogook (m) Eetoolook (m) Pee (f) PETER
 Joanasee (m) PITSEOLAK (m)

══ 4th wife: Kowmadjuk (f)*

retarded son Tukiki (m) Shovegar (f) Kavavow (m)

* A Daughter of Kreemipikulu by an earlier partnership.

156

PARTIAL FAMILY TREE SHOWING ANCESTRY OF AGGEOK PITSEOLAK

Note: Inuit people adopted surnames officially in 1970.

═ Marriage ⌐ Descendants (m) Male (f) Female

Acknowledgments

In Peter Pitseolak's name and on my own behalf I would like to thank the many individuals and institutions who helped make this book a reality.

The project was generously assisted at its outset by the Explorations Program of the Canada Council and sincere thanks go to Dr. William Taylor, Jr., director of the National Museum of Man, Terrence Ryan, art director of the West Baffin Eskimo Co-operative, and Virginia Watt, managing director of the Canadian Guild of Crafts, Quebec, who encouraged and furthered work on the book from the beginning.

It would be impossible to adequately thank Stanley Triggs, curator of the Notman Archives of the McCord Museum, who acted as photographic advisor and spent many hours preparing prints from Peter Pitseolak's negatives for publication. Thanks go also to photographer Charlotte Rosshandler of Montreal who did the initial editing of more than 1000 negatives and made working prints.

In preparation of the text much thoughtful advice came from Beatrice Lambie of Ottawa who edited the manuscript; many helpful suggestions were also made by Alexander Stevenson of the Department of Indian and Northern Affairs, Gloria Pierre, editor of *University Affairs*, Rev. Chris Williams of the Anglican church in Cape Dorset, and journalist and broadcaster Gloria Menard, all of whom kindly read the book in draft form. A debt is owed also to Dr. Margaret Heagarty of New York who first suggested the possibility of interpolating interview material with a written text.

The checking of details, dates and names was made easy by the kind assistance of P. A. C. Nichols, until recently manager of the Transport Division of the Hudson's Bay Company, and by the wonderful memory of L. A. Learmonth, formerly with the HBC, whose knowledge of the south Baffin coast and its personalities seems incomparable. Permission to reproduce the water colour by Peter Pitseolak, now in the collection of the National Museum of Man, and to quote from his book, *Hudson Bay Trader*, was kindly granted by Rt. Hon. Lord Tweedsmuir.

In Cape Dorset, following Peter Pitseolak's death, his widow, Aggeok, spent a week with me, helpfully going through the photographs and supplying names and dates. Peter Pitseolak's older sister, Eleeshushee, who, sadly, died just a few weeks before this book went to press, provided the story of Taktillitak and assisted with other cutlines and footnote material.
The map, which appears to be the first of its kind, was prepared for publication by architect Don Stewart who drew on a draft map made by Peter

Pitseolak before his death and additional material supplied by Bill Kemp,
Fred Schwartz and Erik Val of the McGill University Geography Department.

One of the pleasures of work in the North is the generous hospitality so
often encountered. I would like to thank Ann and Bob Hanson, Colly and
John Scullion, Ann and Des Sparham, Pat and Terrence Ryan and Rev. and
Mrs. Chris Williams for their warm welcome. In particular I owe a great debt
of gratitude to Glen Palmer, my hostess in Cape Dorset for many weeks
over three summers. Without her generous and very practical assistance
this book might have taken far longer to complete.

My final thanks go to my husband for many wise suggestions and tremen-
dous assistance during all the months this book was in the making.

Dorothy Eber

Photographic note

Contact prints for this book were made in a print frame in order to permit
dodging and burning and better control of the printing. Because of the very
intense arctic light most negatives were overexposed and dense. Printing
time varied from a minute and a half to five minutes. Only three pictures
were retouched – one picture was ripped – and while for the purpose of
this book pictures were sometimes enlarged or reduced by the printer, no
photographs have been cropped. It has not yet been possible to identify
the various cameras used by Peter Pitseolak but five negative sizes have
been found: $3\frac{1}{4} \times 5\frac{1}{2}$, $2\frac{1}{2} \times 4\frac{1}{4}$, $2\frac{1}{4} \times 3\frac{1}{4}$, $2 \times 2\frac{3}{8}$, $2\frac{1}{4}$ square.
Except for a small number of original prints for which no negatives existed,
all photographs were printed by Stanley Triggs, curator of photography
of the McCord Museum, Montreal.

Index

Page numbers set in italics refer to captions. The relationship of each family member to Peter Pitseolak is given in parentheses following the name, as are Inuit names of certain personalities.